COLOR HARMONY
IN YOUR PAINTINGS

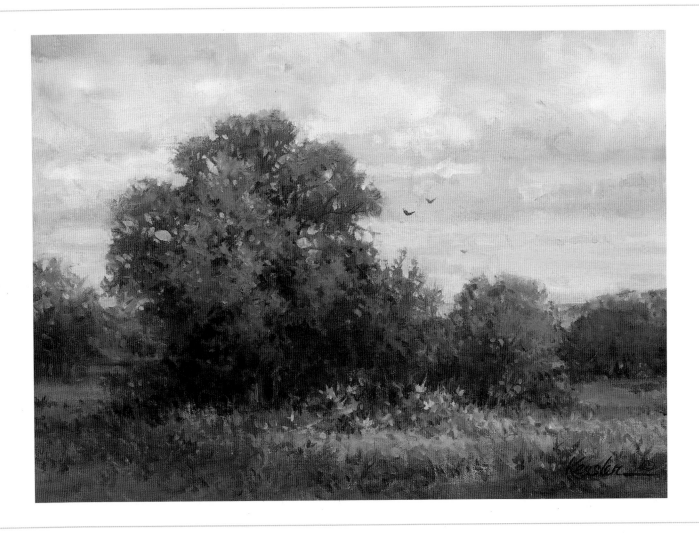

MARGARET KESSLER

NORTH LIGHT BOOKS
CINCINNATI, OHIO
www.artistsnetwork.com

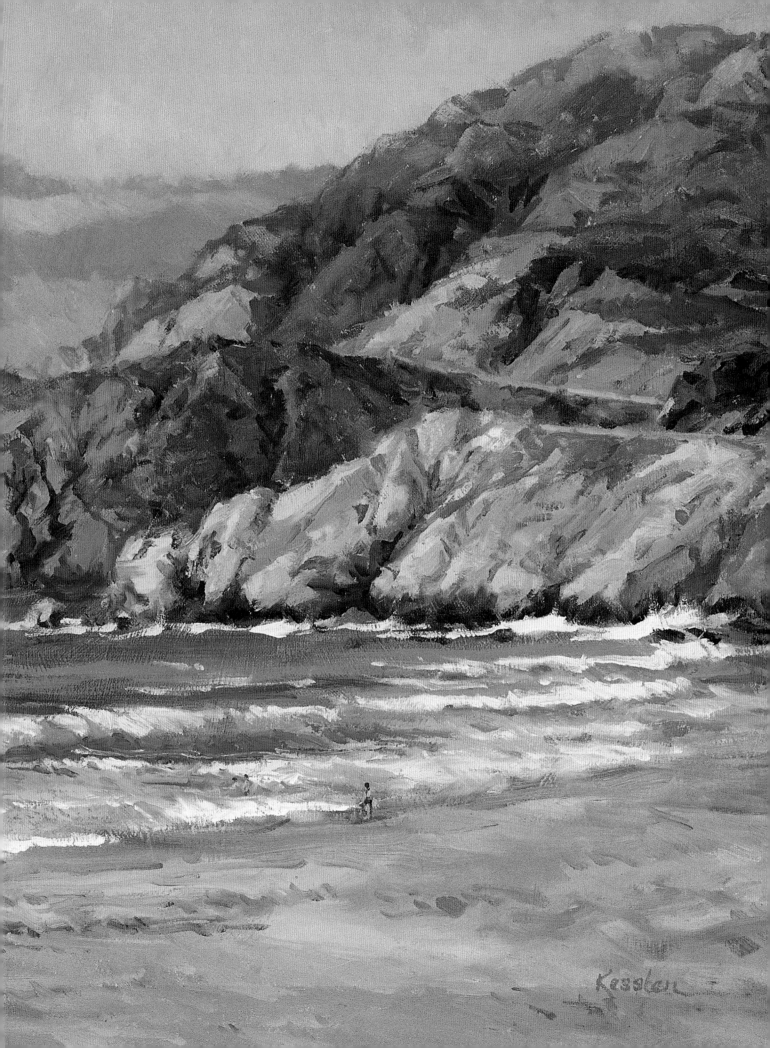

ABOUT THE AUTHOR

Margaret Kessler began painting as a hobby in 1972 when the youngest of her two sons entered the first grade. Since then she's judged art shows, conducted international week-long oil-painting workshops, authored *Painting Better Landscapes* (Watson-Guptill, 1987), and written articles for or appeared in *Southwest Art* and *The Artist's Magazine*. She is also included in *Who's Who in American Art* and *Who's Who in America*.

Margaret's paintings have won major awards, including five Best of Show awards for Artists and Craftsmen Associated (Dallas), where she is a signature member and served as president (1985-1986). Other artistic honors include an appearance in the Arts for the Parks' Top 100 (1989); an honorable mention in the Grand National Exhibition of the American Artists Professional League at the Salmagundi Club (1984); gold, silver and bronze medals from Grumbacher; and a Best Traditional Painting award from Hoosier Salon in Indianapolis (1983).

Margaret lives with her husband, Jere, in Hilltop Lakes, Texas, where they are National Registry Emergency Medical Technician volunteers for the local ambulance service.

Art from pages 2-3:

HIGHWAY ONE • OIL ON LINEN • 20" x 30" (51CM x 76CM)

Color Harmony in Your Paintings. Copyright © 2004 by Margaret Kessler. Manufactured in China. All rights reserved. No part of this book may be reproduced in any form or by any electronic or mechanical means including information storage and retrieval systems without permission in writing from the publisher, except by a reviewer who may quote brief passages in a review. Published by North Light Books, an imprint of F+W Publications, Inc., 4700 East Galbraith Road, Cincinnati, Ohio, 45236. (800) 289-0963. First Edition.

Other fine North Light Books are available from your local bookstore, art supply store or direct from the publisher.

08 07 06 05 04 5 4 3 2 1

Library of Congress Cataloging in Publication Data
Kessler, Margaret.
 Color harmony in your paintings / Margaret Kessler.— 1st ed.
 p. cm
 Includes index.
 ISBN 1-58180-401-6 (hc: alk. paper)
 1. Color in art. 2. Painting—Technique. I. Title.

ND1488.K47 2004
752—dc22 2003064961

Editors: Stefanie Laufersweiler, Maria Tuttle and Jennifer Kardux
Production editor: Layne Vanover
Designer: Wendy Dunning
Production artist: Joni DeLuca
Production coordinator: Mark Griffin

METRIC CONVERSION CHART

To convert	to	multiply by
Inches	Centimeters	2.54
Centimeters	Inches	0.4
Feet	Centimeters	30.5
Centimeters	Feet	0.03
Yards	Meters	0.9
Meters	Yards	1.1
Sq. Inches	Sq. Centimeters	6.45
Sq. Centimeters	Sq. Inches	0.16
Sq. Feet	Sq. Meters	0.09
Sq. Meters	Sq. Feet	10.8
Sq. Yards	Sq. Meters	0.8
Sq. Meters	Sq. Yards	1.2
Pounds	Kilograms	0.45
Kilograms	Pounds	2.2
Ounces	Grams	28.3
Grams	Ounces	0.035

LOOK GRANDPA • OIL ON LINEN • 20" x 30" (51CM x 76CM)

ACKNOWLEDGMENTS

Roses go to my editors, Stefanie Laufersweiler, Maria Tuttle, Jennifer Kardux and Layne Vanover, and to the crew at F+W Publications. Roses also go to all the artists who have shared their color experiences and knowledge with the rest of us through books, visual aids and classes. I wish to bestow special accolades on Cyril Pearce, Hal Reed, Faber Birren, Nita Leland and others for making Albert Munsell's color wheel understandable. Last, but certainly not least, a special rose goes to Jere, my husband of forty years. Here's to another forty!

DEDICATION

In memory of my father,
Kenneth A. Jennings (1908-1961)

Table of Contents

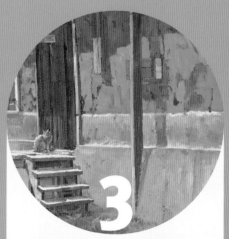

4

MASTERING THE CONTRASTS OF COLOR

58

Contrasting the different elements of color is key to color harmony. Varying contrast of value, temperature and intensity allows you to draw attention to your focal point and play down distractions.

5

HOW LIGHT AND ATMOSPHERE AFFECT COLOR

76

Colors look different depending on whether they are near or far, what time of day it is, and even the weather. Discover how to paint the changing colors of light as they affect your subject, and how to portray the illusion of depth using color. Practice these skills in a demonstration.

6

DESIGNING WITH COLOR

100

Just as you would visualize and build your dream home, so too can you visualize and build your dream painting. This chapter will walk you through a painting process that works, from conception to color planning to final details. A full demonstration ties it all together.

HIGH-COUNTRY CHAMPAGNE • OIL ON LINEN • 18" x 24" (46CM x 61CM)

INTRODUCTION

As artists, we don't paint just so we can reproduce a scene. An artist is not a glorified camera simply there to record the surroundings. Our goal is to make a statement in paint by revealing how we felt about a particular scene on that special day when we were there. Catching your viewer's eye and conveying an emotion from your heart is what painting is all about.

Color is probably the most powerful tool an artist can use to capture a mood or express an emotion. Although it is not absolutely essential to a good design, color is the first and most conspicuous element the viewer sees. Color, a broad subject that seems to intimidate both students and teachers, is a language all its own. If you know the language of color, you can use it to elicit specific emotions from your audience. You can combine colors to shout or whisper, irritate or sooth.

In this book you will find answers to frequently asked questions about color: Why should I use a color wheel? How do I mix pleasant neutrals and darks instead of mud? How can basic color principles help me draw more attention to my center of interest?

Understanding color principles is just the beginning. The challenge is using them. Learn how, when, where, and why you use these principles and you will have the tools for building color harmony. All artists share the challenge of creating an appropriate characterization of each scene we paint using harmonious colors. You can learn to build expressive color statements that will convey any mood you wish to capture.

No matter how important color is, it always surprises me that most artists don't even have a color wheel hanging on their wall for quick reference. With this book, I will introduce you to two color wheels and show you how to use them to apply sure-fire color schemes to specific painting situations. You'll learn how to use color to establish depth and form, create eye-pleasing contrasts, convey different times of day and specific atmospheric conditions, and heighten the expressiveness and impact of your paintings.

Margaret Kessler

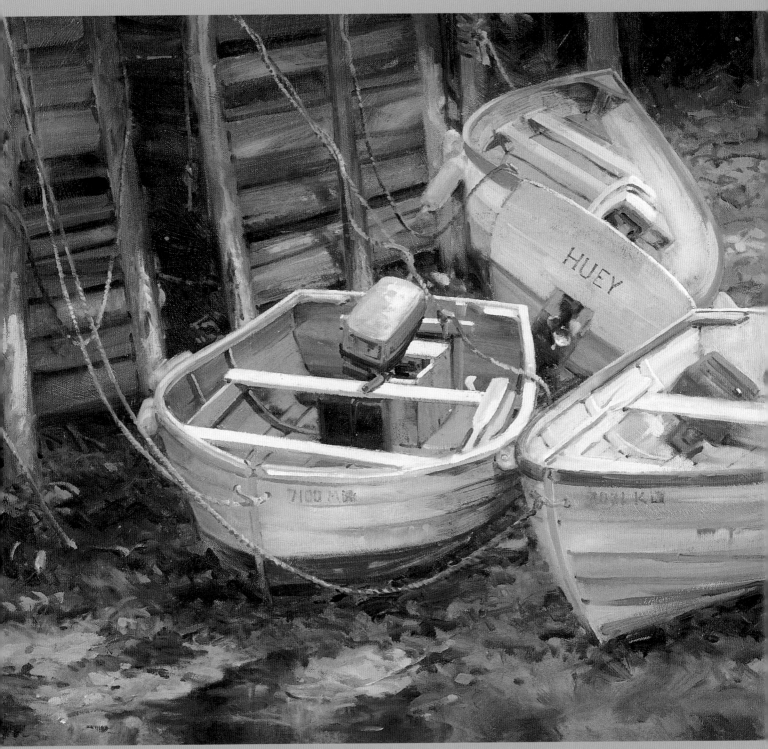

HUEY, DUEY AND LUEY • OIL ON LINEN • 20" x 30" (51CM x 76CM)

1

THE BASICS OF COLOR

The road to color harmony begins with understanding

the characteristics and properties of the colors on your

palette—how to mix and match them so that they work

for you. You must appreciate the full potential of every

color and the effect each color has on another.

The Color Wheel

To understand both the color-mixing capabilities of your paints and the general color schemes available to you, you must be familiar with the color wheel. Wheels can vary, but the most commonly used one is the traditional, triadic color wheel. Its twelve colors are strategically placed in a circle so that equilateral triangles can be drawn to connect three types of colors: primary, secondary and tertiary.

The primary colors—yellow, red and blue—are the basic colors from which all others are derived. Every color your eye sees can be broken down into these three colors. They are unique because you can combine primaries to create other colors (yellows and blues to create greens, for example), but you can't mix any combination of colors to get these three pure colors.

The secondary colors—orange, violet and green—result from mixing together two primaries (red and blue combine to make violet, for example). Tertiaries are the colors that fall between the primaries and secondaries on the color wheel. They result from mixing a primary with one of its neighboring secondary colors. For example, yellow and green combine to create yellow-green.

Colors beside each other on the color wheel are called *analogous*, while colors directly opposite each other on the wheel are *complementary*. Complements can be placed next to each other in a painting for exciting color contrasts, or they can be mixed together to create lively neutrals.

Memorize the color wheel or have a copy of it handy as you paint. It is the most useful visual tool you have for creating color harmony. With a glance at this wheel, you will soon be able to select color combinations that are compatible and expressive of whatever emotion or mood you wish to convey. Try to lay out your palette in approximately the same order. Proper placement of your own favorite tube colors in this arrangement will help you easily see logical color relationships. Select pure, intense colors whose brightness can be adjusted as needed when you paint.

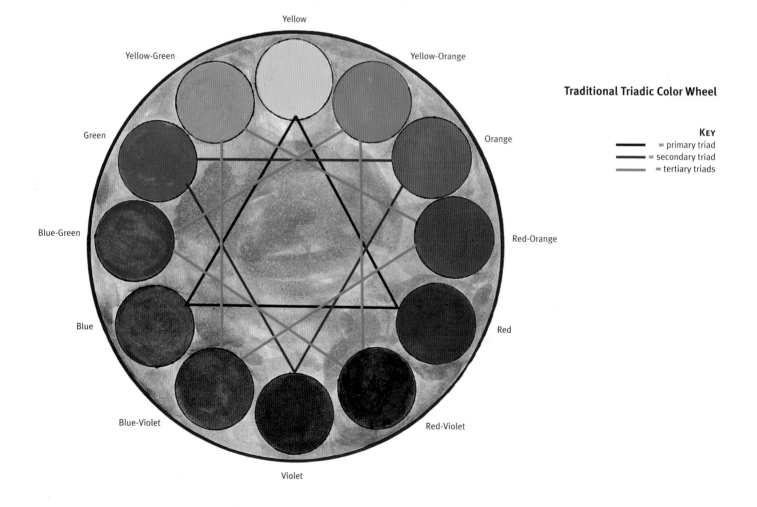

Traditional Triadic Color Wheel

KEY
— = primary triad
— = secondary triad
— = tertiary triads

Value

Value is the relative lightness or darkness of a color. Every color is capable of a range of light to dark. For example, red can range from dark red to light pink when you gradually add increasing amounts of white to the color to create tints.

It's important to note that although value is a property of color, value and color are two separate subjects. Colors that are very different from each other (for instance, red and blue) can have the same value.

When painting, begin by planning your values with a sketch of black, gray and white. No matter what colors you choose for the final painting, the values of those colors should correspond with the lights and darks in the value sketch. The easiest way to evaluate values is to squint your eyes so that you are concentrating on seeing only lights and darks, not colors.

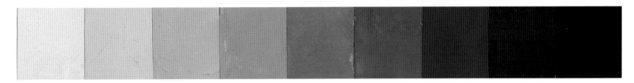

Value Scale
Try painting the range of values for all the colors on your palette, using this value scale as a guide. You'll find that each color has its own range of values. Knowing the value range of each color will expand your palette.

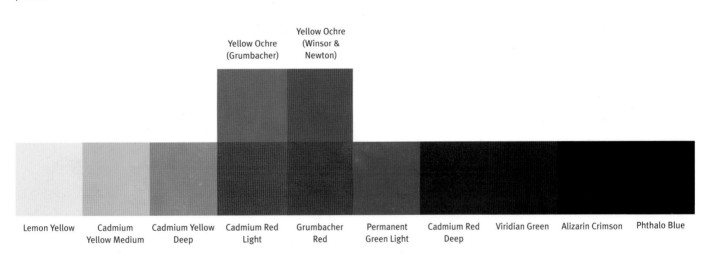

The Inherent Values of Tube Colors
Every color on your palette inherently has a corresponding value, making some colors naturally darker or lighter from the start. The commercial oils shown above are placed in order from light to dark. You may be surprised to learn how the inherent values of colors differ from brand to brand. Notice the one-step difference in value between the Grumbacher and Winsor & Newton brands of Yellow Ochre.

Temperature

Colors can appear to be warm or cool in temperature. It is easy to understand the principle of color temperature by looking at a basic color wheel. Yellows, oranges and reds are generally thought of as warm colors, and blues, greens and violets are considered cool. Seems easy, right?

The catch is that color temperature is always relative. You judge temperatures by observing how colors relate to each other. For example, red is cooler than red-orange, but warmer than red-violet. Each family of colors has warm and cool hues, so it's possible to have warm blues and cool reds.

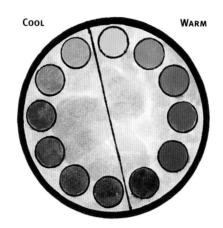

COOL WARM

Warm and Cool Colors on the Wheel
Compare sides of this color wheel. One side is warm—yellows, oranges, reds; the other is cool—violets, blues, greens. When looking at the color wheel as a whole, the warms and cools appear to be evenly distributed.

However, color temperature is relative. Now choose any single color on the wheel and look at only the two colors on either side of it. For example, yellow-green is cool when compared to yellow, but warm when compared to green.

WARM ⟶ COOL

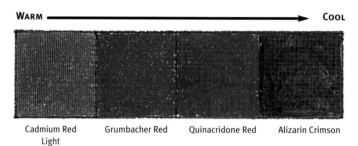

Cadmium Red Light Grumbacher Red Quinacridone Red Alizarin Crimson

Temperature Variations of Red
Within any given color, the warmest hue is the one with the most yellow in it. This is a basic principle used when comparing color temperatures. For instance, warm yellow appears in Cadmium Red Light but not in Alizarin Crimson, so Alizarin Crimson appears cooler.

WARM ⟶ COOL

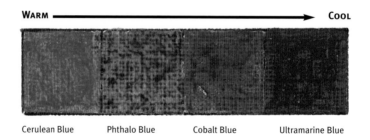

Cerulean Blue Phthalo Blue Cobalt Blue Ultramarine Blue

Temperature Variations of Blue
The yellow in your warm blue (Cerulean) disappears as you gradually step toward cool blue (Ultramarine). Also, the red that is in Ultramarine cools the blue hue, moving it toward violet and away from greenish blue.

Intensity

Intensity, or the measure of brightness or dullness of a color, is as important as value and color temperature. The key to making your paintings "pop" is to juxtapose bright hues against dull ones. There are subjects that call for very bright colors, but if every area of your painting is vivid, all areas will compete for attention and your color harmony will collapse.

There are several different ways to increase and decrease intensity to accomplish the results you want. Keep in mind that it is easier to mute bright colors than to intensify dull ones.

This red square looks more intense when surrounded by a neutral color, brown. You can also intensify a color by juxtaposing complements—red and green—and by contrasting light and dark colors.

Increasing Intensity

To brighten a dull or tinted color, add a warm color to the mixture. However, be careful: When the three primary colors (red, yellow and blue) are mixed together, the color is neutralized rather than made brighter. It is important to understand the proportions of the primaries contained in the colors you're combining. For example, if you try to re-energize a cool blue with a warm red instead of a cool one, you'll neutralize it, as there is a great deal of the third primary color (yellow) in the warm red.

PHTHALO BLUE + LEMON YELLOW AND WHITE = INTENSIFIED BLUE
This warm blue has yellow in it, so to brighten it add more yellow.

ULTRAMARINE BLUE + QUINACRIDONE RED = INTENSIFIED BLUE
To re-energize this cooler blue, add a cool red.

Decreasing Intensity

Compare these four methods of reducing the intensity of a bright color (Cobalt Violet). Muting a color by adding its complement is ideal.

COBALT VIOLET + TITANIUM-ZINC WHITE
As you lighten a color, you reduce its intensity. But, if you do this with tubed white (a cool color) without modifying it with hints of warm color, the result looks chalky.

COBALT VIOLET + IVORY BLACK
As you darken a color, you reduce its intensity. But, colors darkened with black often look unnatural.

COBALT VIOLET + PAYNE'S GRAY
You can change the intensity of a color without affecting its value. But, when used exclusively, this cold dark is a boring way to adjust the intensity of your colors.

COBALT VIOLET + MIXED YELLOW-GREEN (CADMIUM YELLOW MEDIUM AND PHTHALO BLUE)
For the best results, decrease the intensity of a color by adding its complement.

A Painter's Palette

Although color choices are personal, I find the palette below to be ideal. With these colors, and the addition of Titanium Zinc-White, you can paint anything you want—still lifes, portraits or landscapes. The more you work with them, the better you will understand how the colors relate to each other. For example, you can create a true blue (Cobalt Blue) by mixing Ultramarine and Phthalo blues. A cool dark accent—a more lively substitute for monotonous black—can be created by mixing Phthalo Blue and Cadmium Red Deep. Since these are combinations of

colors already on your palette, all of your colors are closely related. Color harmony is almost guaranteed even before you begin laying paint to canvas.

Explore the differences and similarities in colors from brand to brand. Several of the colors on my palette are Liquitex brand, which is no longer commercially available. However, you can match the colors shown in the illustrations below with different brands. You will find that many colors made by a particular manufacturer can be substituted for colors from another manufacturer. For

instance, Winsor & Newton's Permanent Rose or Grumbacher's Thalo Red Rose can be substituted for Grumbacher's Quinacridone Red. They are preferable to Alizarin Crimson, as it is nearly purple and quite intense.

Once you have selected a set of colors for your palette, stick with them. Learn their placement as you would the letters of a keyboard or the keys of a piano to avoid the hunt-and-peck method of painting.

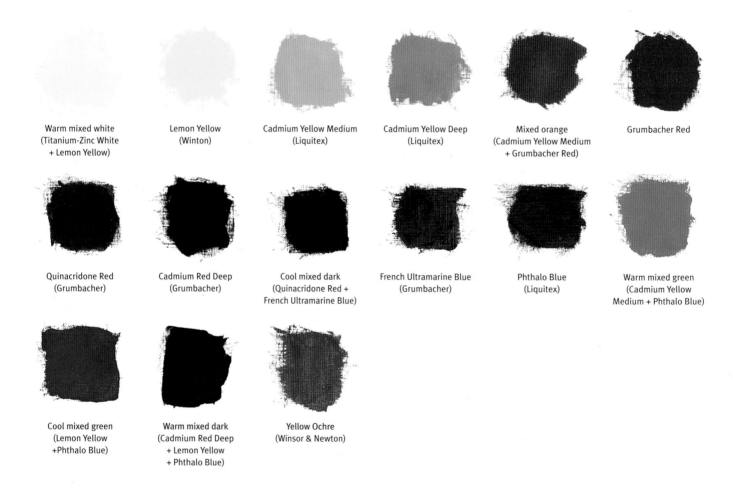

Warm mixed white
(Titanium-Zinc White
+ Lemon Yellow)

Lemon Yellow
(Winton)

Cadmium Yellow Medium
(Liquitex)

Cadmium Yellow Deep
(Liquitex)

Mixed orange
(Cadmium Yellow Medium
+ Grumbacher Red)

Grumbacher Red

Quinacridone Red
(Grumbacher)

Cadmium Red Deep
(Grumbacher)

Cool mixed dark
(Quinacridone Red +
French Ultramarine Blue)

French Ultramarine Blue
(Grumbacher)

Phthalo Blue
(Liquitex)

Warm mixed green
(Cadmium Yellow
Medium + Phthalo Blue)

Cool mixed green
(Lemon Yellow
+Phthalo Blue)

Warm mixed dark
(Cadmium Red Deep
+ Lemon Yellow
+ Phthalo Blue)

Yellow Ochre
(Winsor & Newton)

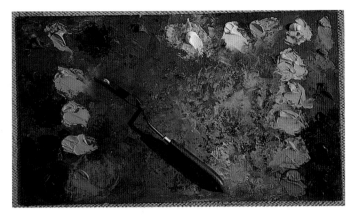

My Palette

No matter what medium you choose, place your colors on the palette in approximately the same order they appear on the color wheel. For oils, adding a little white to each color creates tinted hues (shown here inside the outer rim of main colors). This handy step between light and dark saves you time and allows you to concentrate on your painting with fewer interruptions for mixing.

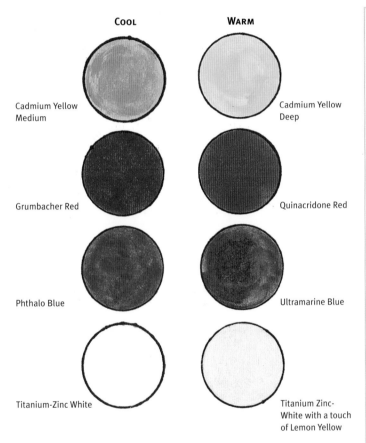

COOL	WARM
Cadmium Yellow Medium	Cadmium Yellow Deep
Grumbacher Red	Quinacridone Red
Phthalo Blue	Ultramarine Blue
Titanium-Zinc White	Titanium Zinc-White with a touch of Lemon Yellow

Mixing Your Entire Palette From Primaries

Technically, you can create all the colors of the rainbow with just the three primary colors. The colors in nearly every painting in this book were created from only eight tubes of paint: a cool and a warm each of red, yellow, blue and white. With these few hues, a little logic and some experience, you can mix any color you want.

Start with bright hues of these colors on your palette and mix your secondaries and intermediates. From there, you can neutralize those brights all you want, but keep in mind, once they're neutralized, you cannot brighten them back to full intensity. With this control over color, you are free to concentrate on what you want to say with paint.

● ● ● ●

CHOOSE YOUR PALETTE SURFACE WISELY

Watercolorists have it easy when choosing a palette surface. They apply color to white paper, so mixing color on a white palette is ideal for previewing how the colors will actually look on your paper. Oil painters have a different situation. Usually one of the first things you do when starting an oil painting is to tone the raw white canvas with an overall wash of color. Once the white surface is covered, white is no longer a desirable palette color. In fact, it can lead to real trouble as you mix colors, since they will look different than you intended once they are applied to the toned canvas.

It is logical, therefore, to mix your colors on a palette that is similar in color and value to one of your typical paintings—most likely a middle value, neutral-color palette rather than white. There are several palette options to choose from. Commercial solid-wood palettes or the smooth side of a piece of tempered Masonite work great. These boards must be saturated with linseed oil before using them, or the linseed in your paints will quickly soak into them. Also, these boards are usually too dark as purchased—especially Masonite. For most artists, anything much darker than a brown paper bag needs to be modified. You can do this by taking your palette scrapings (left-over paints) and blending them together somewhat on your board. Neutral and warmish browns make a nice surface color to get you started.

Keep your entire palette surface smooth, or you will ruin your palette knife when you mix paints on it. The more you use the board, the better the seasoning will become and the better suited its basic color will be for you. To clean it, scrape with a palette knife and wipe with turpentine and paper towels.

Make your palette as large as you can comfortably handle. Small palettes limit the space you have to mix and modify colors. Traces of unwanted color will contaminate your mixtures if you don't frequently stop and clean it. Also, freedom of space on your palette encourages free and exciting brushwork on your canvas. Picking around with little spots of palette colors can result in paintings composed of similarly picky little spots.

Mixing Secondary Colors

Try mixing your own oranges, violets and greens from your primaries instead of buying them premixed. The secondary colors you mix, as well as any neutrals you mix from them, will then be perfectly compatible with the particular primaries on your palette. For example, say you decide to create a green by mixing the yellow and blue from your palette instead of buying a tube color such as Viridian Green. The resulting green will automatically be in harmony with the rest of the colors you mix using the same primaries (e.g., an orange created with the same yellow). If you stick to a palette composed of secondary colors made from the primaries already on your palette, color harmony is just around the corner.

If you understand the makeup of each color you use, it is easy to mix new colors and to create the hues you want—light or dark, warm or cool, bright or dull. The key is to remember that if you mix more than two primaries, your secondary color will become neutralized or grayed.

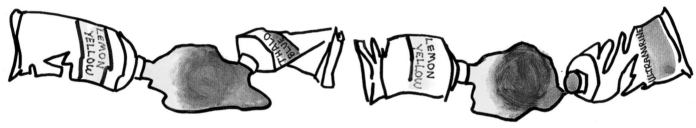

Bright Green
Sometimes secondary colors can lose some of their powerful brightness when you mix them yourself, but if you start with pure colors you can create vivid secondaries. You can mix a bright green by combining Lemon Yellow with Phthalo Blue rather than Ultramarine Blue. That's because neither Lemon Yellow nor Phthalo Blue contains a trace of red, the third primary color; you are dealing with a pure yellow and a pure blue.

Dull Green
Lemon Yellow mixed with Ultramarine Blue is an entirely different story. Ultramarine is a purplish blue because it has traces of red in it. If you use this blue, you are indirectly working with all three primaries. Remember that adding the third color of any triad grays the mixture of the other two colors.

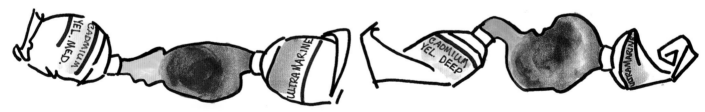

Duller Green
Because Cadmium Yellow Medium contains a trace of red, you will get a duller green when you mix this yellow with Ultramarine Blue.

Dullest Green
If you mix Cadmium Yellow Deep with Ultramarine Blue, you will automatically create a neutralized green because of the large amount of red in these two colors.

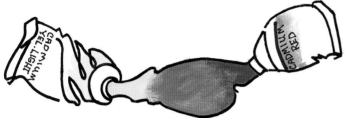

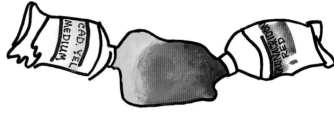

Bright Orange

For a bright orange, try mixing a true red and a true yellow, such as Cadmium Red or Grumbacher Red with Cadmium Yellow Light. To mix this new secondary color, you are still working with only two primaries, so your new color will be clean and bright.

Dull Orange

If you create an orange by mixing Cadmium Yellow Medium and a red that contains a trace of blue, such as Permanent Rose or Quinacridone Red, you will start to neutralize your secondary color.

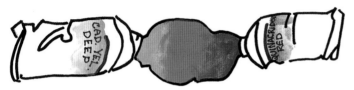

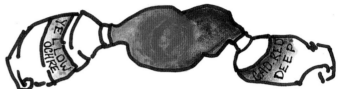

Duller Orange

The additional red in Cadmium Yellow Deep and the blue in Quinacridone Red neutralize the resulting orange even more.

Dullest Orange

For a really earthy orange, combine Yellow Ochre and Cadmium Red Deep. Each of these colors is a combination of all three primaries.

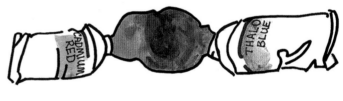

Bright vs. Dull Violets

For intense violets, avoid mixing colors that contain yellow. Mix a bluish red with a reddish blue. Avoid Phthalo blues, Ceruleans, Cobalts and most Cadmium reds, as they contain some yellow and, as a result, will neutralize your violet. If you want to neutralize your bright colors, it is better to do this during the painting process instead of including them on your basic palette. Once a color is grayed down, it is difficult to make it bright again without creating a muddy hue.

Create Neutral Colors With Primaries

Up until this point you've learned that to maintain bright mixtures of color, you should *not* mix all three primaries. But your paintings most likely won't be composed of only vivid colors; oftentimes you will need neutrals in order to complete a scene and convey a mood. By combining the three primary colors (or their close neighbors on the color wheel), you can produce neutrals in middle and dark values. Add white to lighten these neutrals.

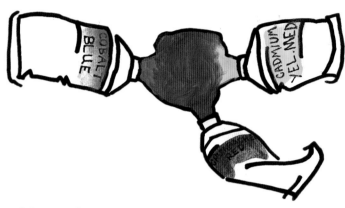

Bright Neutral
A middle-value, relatively bright neutral mixed from Cadmium Yellow Medium, Grumbacher Red and Cobalt Blue.

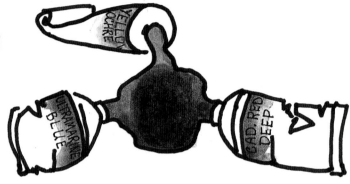

Dull Neutral
A darker, duller neutral mixed from Yellow Ochre, Cadmium Red Deep and Ultramarine Blue.

Grays Can Set the Mood
These muted colors were created by mixing the primaries Quinacridone Red, Cadmium Yellow Medium and Ultramarine Blue. The canvas was toned with a wash of these three basic colors, which I then allowed to blend together on the canvas to create the mood for a cold, damp day near the ocean. In order to effectively capture this mood, I continued combining these colors throughout the painting process. Adding a flash of bright yellow, like a bright light, would have broken the mood.

LOBSTERS • OIL ON LINEN • 18" x 24" (46CM x 61CM)

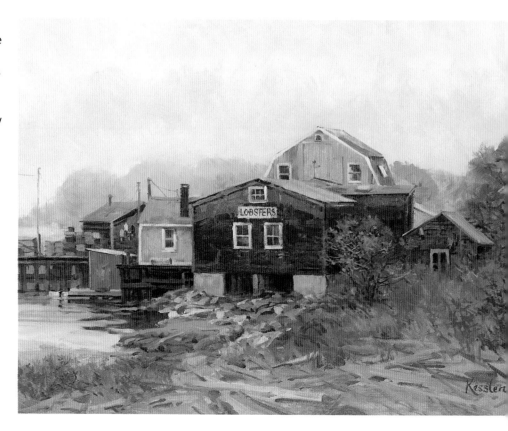

Combine Complements for Lively Neutrals

Each color on the wheel has only one complement, or opposite. If the color you select is warm, by comparison its complement will be cool. For example, red is warm and green is cool.

When mixed together, complements can create lively neutrals. Complements neutralize each other because together they contain all three primaries. If you analyze any pair of complements, you will find that, indeed, all three primaries are present. The complements are a shortcut to the neutrals. It's simpler to create just the neutral you want by blending orange and blue instead of starting with red, yellow and blue.

To neutralize red's brilliance, mix a little green with it to make a brownish red. Mix oranges and blues to make beautiful grays. Yellows mixed with violets create earthy neutrals. Practice mixing with varying amounts of complements to discover the range of grays and browns you can achieve.

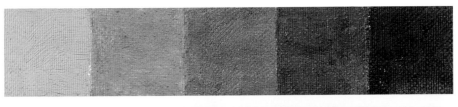

Neutrals Mixed From Complements

Call them whatever you want—browns, grays, muted colors, earth colors—neutrals are a challenge to mix properly. Most students avoid mixing them by reaching for such commercially made hues as ochres, siennas and umbers. Introducing these new tube colors can interfere with your basic palette's color harmony. Mix your own neutrals by combining opposites on the color wheel, and you will discover many exciting hues that will enhance your chosen color scheme.

AN EASY WAY TO REMEMBER THE COMPLEMENTS

Even without a color wheel handy, complementary colors are easy to identify. You can determine the complement of a specific color simply by knowing the missing color of the red-yellow-blue triad. If, for example, you want to find the complement of yellow, subtract that color from the primaries. What's left? Red and blue. Now, in your imagination mix those two colors and you have violet—the complement of yellow. To find the complement of a tertiary color such as blue-green, simply name the complement of each individual color, and combine them. Therefore, the complement of blue-green is red-orange.

Visually Mixing Complements for Neutrals

When you mix complements together, they neutralize each other, graying their natural brilliance. When complementary shapes are placed side by side, they create exciting visual energy. When small brush marks of complementary colors of the same value are distributed evenly on your painting surface, they will appear to blend from a distance, as the viewer's eye does the mixing. This broken color appears to combine into beautiful shades of gray and brown.

By varying the quantity of each of the complementary colors and by adding white to change the value, the neutrals you create can be light or dark, warm or cool, bright or dull. This broken-color technique allows you to create more vibrant neutrals than you would by thoroughly mixing complements, adding black or white to a color, or painting with premixed neutrals such as ochres, siennas and umbers.

Contrasting Complements
Opposites on the color wheel can be placed next to each other for strong, exciting color contrasts. Juxtaposed, these opposites will intensify each other even when they are similar in value.

Physically Mixed Complements
When you physically mix complements, they create neutralized colors that are obviously compatible with the two original colors. To keep these hues lively, don't overmix them.

Visually Mixed Complements
Hold this illustration at arm's length and squint your eyes. Notice how the dots of orange and blue visually mix for vibrant neutrals.

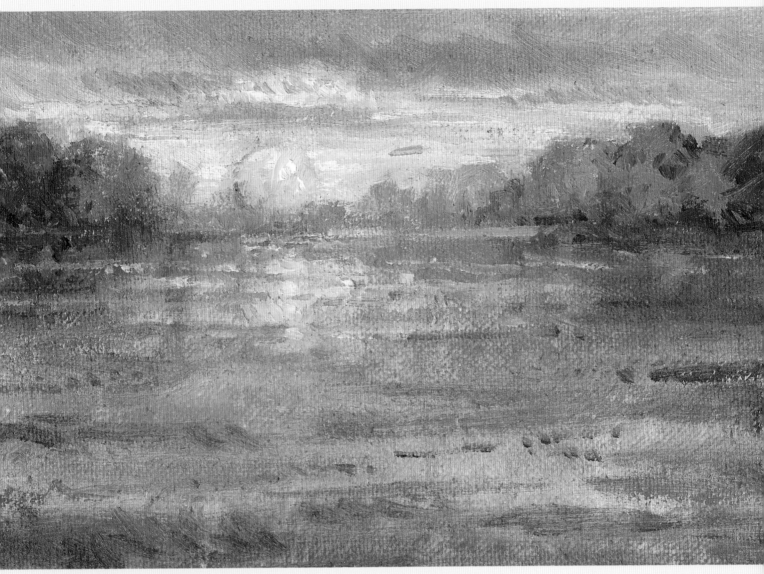

The Versatility of Complementary Colors

This sunset study uses complements in a couple of ways for stunning results. Orange is the dominant color in this blue-orange complementary scheme. For contrast, complements are juxtaposed near the focal point: the setting sun. In other places, blended complements create compatible grays, providing restful pauses among the exciting colors. The scene is enhanced with dramatic value changes of both colors from light to dark.

SUNSET IN ORANGE AND BLUE • OIL ON COTTON • 4" x 6" (10CM X 15CM)

Ten Tips for Mixing Color

1. Develop the habit of starting with the lightest color. For a light blue, gradually add blue to white. For green, start with yellow and add blue a little at a time. If dealing with a phthalo hue, modify with a speck at a time. It's strong stuff!

2. When modifying color, question the type of change that is actually needed. If you are trying to match the green on your canvas to a green in a landscape, ask yourself, "Is the color too light or dark, too warm or cool, and/or too bright or dull?" Then modify it accordingly until you have the match you want. If you decide that the green is too warm and too bright, you will know what changes to make: cool and dull it.

3. As you mix new colors, start with warms and then cool them as necessary as you're painting. It is far easier to cool a warm than to warm a cool. If you start out with a green that is too cool (too blue-green), it may take all the yellow on your palette to warm it back up; whereas, yellow-green can be cooled quickly with just a little blue.

4. Use a flexible palette knife rather than a brush to mix colors on your palette and sometimes to place colors on your canvas. Brushes retain traces of pigments that will contaminate your new mixtures, resulting in muddy colors, unless they are cleaned thoroughly with each color change. It's better to mix color with a knife. However, don't let paint dry on the blade; combine that with a rough palette surface and you will soon bend and ruin your blade.

5. Don't overmix colors on your palette. This can take the life out of a color. A lightly mixed, almost marbleized effect is more interesting to the eye and keeps your painting looking fresh.

6. Get to know the properties of different whites. Every tube white has characteristics of its own and affects your colors accordingly. Titanium is opaque and bluish. Zinc white is transparent and colorless, but becomes brittle with age. Titanium-Zinc White is not too brittle, and the mixture gives your color a pearly luster that enhances your tints.

7. Different commercial brands for colors of the same name may be slightly different hues. One manufacturer's Cadmium Yellow Deep is a near match for another's Cadmium Orange.

8. Avoid chalky colors by re-energizing your tints. If using white (a cool hue) to create tints, you may have to re-warm some of the naturally dark colors that require a lot of white to lighten them. Add a little Lemon Yellow to re-energize your tints of yellow-orange, orange and warm reds. A pale tint of Phthalo Blue can use a tad of Lemon Yellow, too. A touch of Lemon or Cadmium Yellow Medium can re-warm your light-green tints. Similarly, adding some touches of Quinacridone Red can bring pale hues of Ultramarine Blue or violet back to life.

9. Save time by tubing some of your mixed colors and tints. You can find empty paint tubes in some art catalogs and supply stores. With your painting knife, you can fill these tubes from the bottom. Fold the end of the tube and crimp it with needle-nose pliers and your paint will stay fresh for years.

10. Delay the drying process of the oils on your palette by putting it in your freezer when not in use. Cover it with plastic wrap so the paint doesn't transfer to your frozen food packages.

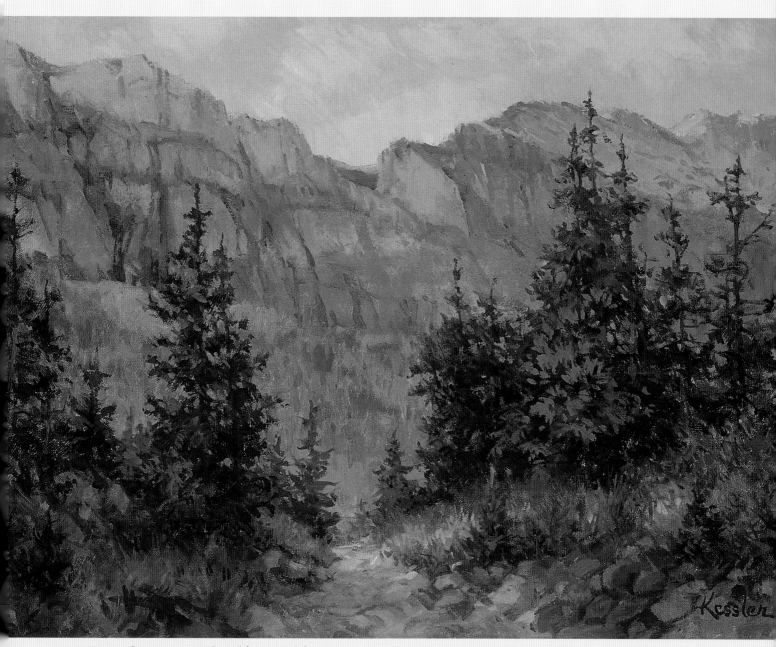

SKYSCRAPERS • OIL ON LINEN • 18" x 24" (46CM x 61CM)

SOMETHING IN THE AIR • OIL ON LINEN • 20" x 24" (51CM x 61CM)

2
CHOOSING A COLOR SCHEME

Learn to select color schemes that are harmonious and expressive of the underlying spirit of your subject. Let's take a closer look at the traditional triadic color wheel and the variety of color schemes found on it.

What Colors Can Mean

Although color has a universal appeal to children and adults, artists and non-artists alike, our cultural customs and traditions generally determine our response to it. For example, what color symbolizes "sacred" to you? Deep purple? Royal blue? You probably didn't choose yellow, but some say that there are primitive tribes who consider that color sacred because the sun, the source of life, is yellow. You may think black is the universal color for grief and death; however, in Japan one wears a white kimono to a traditional funeral.

Some objects naturally evoke a particular color: the grass is green and the sky is blue. Paradoxically, some colors elicit specific expectations; for example, white symbolizes clean and sterile. In a hospital, how would you respond if a nurse dressed in a black uniform entered your room?

Whenever possible, utilize symbolic colors and intelligent manipulation of these colors in your paintings to dramatize the mood you want to convey to the viewer. Be creative. You can change the viewer's perception of a subject or scene simply by altering the color scheme. Try changing the *local color* (the actual color) of your subject. Don't paint a Holstein cow black and white, paint it dark purple and light yellow! Choose unique colors that breathe new life into your subject. That is something the camera can't do.

COMMON COLOR CONNOTATIONS

What images, ideas and feelings come to mind when you think of these colors?

Red = Rage, blood, fire, danger, courage, bravery, excitement, passionate, sexy.

Yellow = Caution, hot, sunny, light, bright, radiant, joyful, cowardly, jaundiced.

Blue = Water, sky, heavenly, cold, distant, masculine, restful, melancholy.

Orange = Warmth, autumn, energy, tension, cheerful, lively.

Green = Growth, nature, hope, fresh, fertile, gentle, pastoral, envious.

Purple = Shadows, religion, fantasy, magical, royal, dignified.

Black = Dark, night, death, mourning, gloomy, sorrowful, dirty, wicked, evil, dramatic.

White = Winter, peaceful, glorious, pure, innocent, clean, pale, weak, harsh.

Brown = Autumn, earthy, rustic, basic, natural, reliable, conservative.

COLORFUL EXPRESSIONS

Here are some commonly known colorful terms we use to be expressive in everyday language:

Green with envy

True blue

The blues

A blue blood

A blue-collar worker

Blue ribbon

Yellow bellied

White hot

Caught red-handed

Too much red tape

Red-letter day

Red hot

Seeing red

Black market

Blacklisted

Little black book

A black-tie event

Black magic

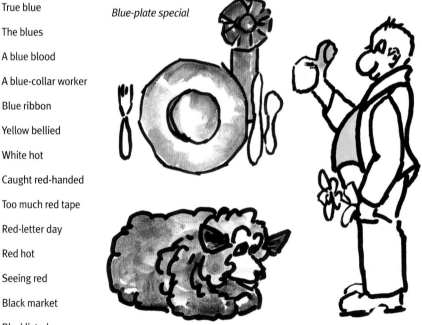

Blue-plate special

Black sheep

Green thumb

The Psychological Effects of Color

Several different versions of the color red are shown here. Even though they are essentially the same color, each unique version can trigger different feelings and emotions. Changing the value, temperature and/or intensity of a color can completely change our reaction to it. Just think, if you can do this much with one color, imagine what you can say with many different colors!

Light Red
Delicate, feminine.

Dark Red
Life, courage.

Warm Red
Fire, passion.

Cool Red
Rosy, romantic.

Bright Red
Danger, childlike.

Dull Red
Rusty, earthy.

Why Choose a Color Scheme?

Using expressive colors is not enough; color harmony is also essential. To express yourself with a consistent and pleasing arrangement of harmonious colors, you must understand the concept behind a basic color wheel and the variety of color schemes found on it. These schemes help you decide which colors work best together to convey the essence of your subject.

Also, you must study how the Masters made color work for them. Read. Take classes. Experiment. Observe your own color preferences, and consider the psychology and symbolism of color. Then progress beyond the theoretical so you can start expressing yourself with conviction in color.

Remember that rules are made to be broken, but break them intelligently. Moderation is the key here. Rules and principles provide a good start but can restrict your creativity. On the other hand, spontaneous selection of random colors may lead to chaotic color statements. Strive to integrate your knowledge of color with your painting ideas. In the end, color choices rest with you.

Keep in mind that no choice is right or wrong—just more or less effective.

As there are many different color schemes, there are different color wheels. Again, none is right or wrong. Each theory is valid on its own terms, so don't exclude the others as incorrect. Instead, learn to visualize your painting in several color schemes derived from various color wheels, and then simply select the one you like best.

On the following pages, we'll look at some popular color schemes found on the traditional triadic color wheel.

Chaotic Colors
Too many unrelated colors can spoil the harmony. Pretty colors that are just randomly placed often result in a chaotic look that won't support your subject.

Harmonious Colors
Link colors together by repeating your basic colors and their complements throughout your painting. Exercise repetition with variety by changing the colors a bit as you repeat them. This will support your overall color scheme without making it predictable.

Make color connections. In this example, bounce the red of the barn into the nearby yellow trees. Work the complement of your red barn appropriately into those trees by suggesting a few green leaves near their core. This same green can serve as the local color for the grass. Modify the barn's local color when painting its shadows instead of adding unrelated darks. Maintain the dominant analogous color scheme of yellow-red-orange, but add complements to excite the eye.

Primary Color Scheme

The three primary colors construct the framework of the triadic color wheel. Favorites of the artist Grandma Moses, they are both direct and energetic. Like complementary colors, primaries can be mixed to neutralize or be placed side by side to make a bold, dramatic statement. Always let one of the primary colors take centerstage.

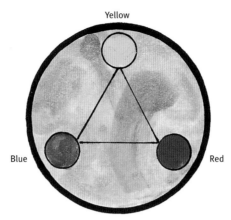

Primary Color Scheme

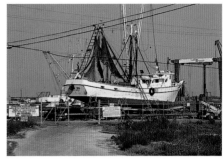

Reference Photo
At first glance you might be tempted to make this scene a blue and white painting, but some touches of red and yellow—the other primary colors—will bring it to life. Blue and its complement orange would also work well.

A Primary Color Scheme for a Marina Scene
Blue is clearly the dominant color in this seaside scene, and the other primary hues act as supporting colors. The red truck on the left is balanced with various reds on the far right, on the lifesaving ring hanging on the ship's newly painted cabin, and a third time near the sign. I used yellow at the base of the sign, and the sunny side of the boat has a yellow tint. Yellow Ochre, a distant relative of yellow, is seen on the road, in the weeds surrounding the shipyard, and on the boat. I related the Ultramarine Blue sky to the rest of the painting by adding touches of red and Yellow Ochre.

Wet Paint started with an overall wash of Yellow Ochre and Quinacridone Red. By juxtaposing the three primary colors as often as possible rather than combining them, the painting stays bright and exciting. The complexity of the painting was enhanced with touches of secondary color—orange, violet and green—that do not overwhelm the overall color scheme.

WET PAINT • OIL ON LINEN • 18" x 24" (46CM x 61CM)

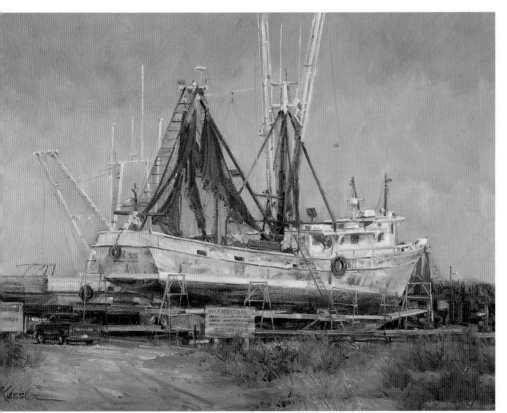

Secondary Color Scheme

The secondary colors adapt particularly well to nature scenes—so well, in fact, that it is easy to slip into formulaic use of them. Green grass, orange autumn trees and distant violet mountains can become cliché. Don't be afraid to stray from this formula. Creatively reflect oranges and violets into the green grass, greens and violets into the orange tree and so on. To avoid monotony, paint green trees with violet cast shadows on orange grass.

As with the primary color scheme, allow only one of the secondaries to emerge as the star of the show.

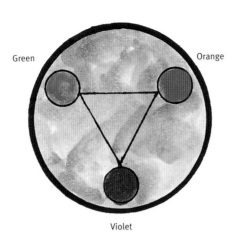

Green Orange

Violet

Secondary Color Scheme

Reference Photo
This scene says green! The secondary color scheme includes green and would better suit this subject than the complementary color scheme of green and red. However, you could justify using a touch of the complementary red along with the secondary color scheme.

A Classic Landscape Color Scheme
In this landscape, the secondary color scheme is ideal for portraying a variety of colors and subjects in the sparkling sunlight. Green is the dominant color, appearing in the trees and vegetation. Notice the various violets that appear in the sky, mountain shadows, valley floor and the foreground. Oranges work in the middle-ground autumn trees, the sunny areas of the mountains, and the dramatic flash of color (the building) on the right.

The contrast of lights and darks enriches the vitality of the colors, adding to the excitement of the beautiful scenery. Your eye moves down the lines of the road, past the barn, and across the valley to the mountaintops, which are the focal point.

ROAD TO PARADISE • OIL ON LINEN • 18" x 24" (46CM x 61CM)

Practicing a Secondary Color Scheme

Let's use the secondary color scheme for a simple subject: potted violets.

MATERIALS

SURFACE
6" x 6" (15cm x 15cm) canvas

BRUSHES
1-inch (25mm) housepainter's brush

No. 1 round bristle

Nos. 1 and 8 filbert bristle

No. 4 round sable

OILS
Cadmium Yellow Medium

Dioxazine Purple

Grumbacher Red

Lemon Yellow

Permanent Green Light

Titanium-Zinc White

Ultramarine Blue

Viridian Green

Yellow Ochre

OTHER
Gesso

Palette knife (for mixing)

Paper towels

Pencil and ruler

Turpentine and jar

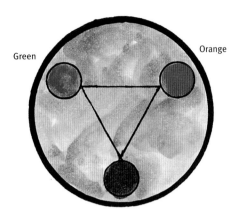

Secondary Color Scheme

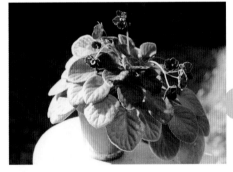

Reference Photo
The secondary color scheme is a natural choice for this subject. For the painting, we'll play up the sunlit leaves for the center of interest.

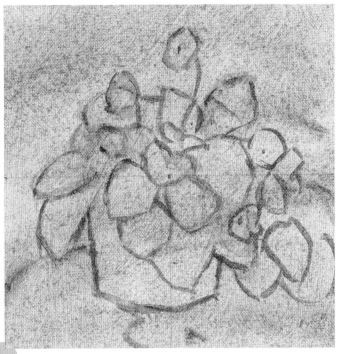

1 TONE THE CANVAS AND MAKE A DRAWING

For texture, apply gesso to your canvas with your housepainter's brush using short, swirling brushstrokes. Let it dry completely. Use a paper towel to tone the canvas with Yellow Ochre thinned with turpentine. Let this dry and brush away any paper residue left on the canvas. Grid your canvas, marking the center.

Load a no. 1 round bristle with Yellow Ochre and a touch of Dioxazine Purple and draw the basic shapes of the violet and the pot.

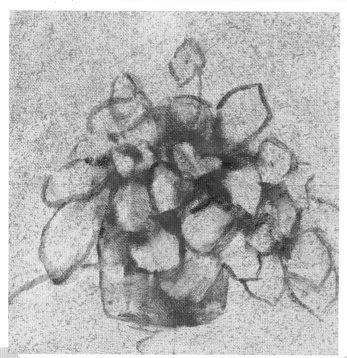

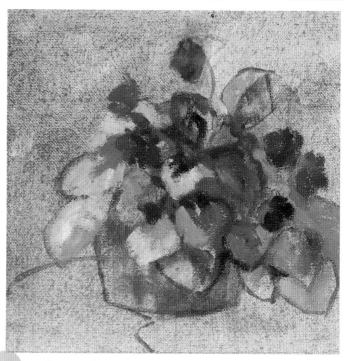

2 INDICATE WARM DARKS

Mix your own orange by adding Cadmium Yellow Medium to Grumbacher Red. With a no. 1 filbert, block in the warm darks of the plant and the local color of the pot. Check your composition to make sure that your subject is well balanced. You don't want the pot to look as if it will tip over due to the lopsided growth of the plant.

3 ADD LOCAL COLOR AND VALUES

After extending the pot on the right to restore balance, start blocking in the other secondary colors, concentrating on the lights and darks. To create a variety of hues and values in the leaves and blossoms, use both a warm green (Permanent Green Light) modified at times with white and/or Cadmium Yellow Medium, and a cool green (Viridian Green) modified with Ultramarine Blue and/or Dioxazine Purple. Then, to set the stage for what will be the sunny center of interest, use a no. 8 filbert to darken the background in the upper left with a light wash of Viridian Green and Dioxazine Purple.

● ● ● ●

A WORD ABOUT BRUSHES

Almost exclusively, I use filbert bristle brushes in nos. 1 to 6, 8 and 10, as well as a no. 12 for larger canvases. I also have nos. 1 and 2 round bristle brushes on hand for my initial drawing and final details. If you like round bristle brushes, buy larger ones too.

Working with a worn-out brush is the most overlooked handicap students have. Frequently compare the bristles of your used brushes with a similar-sized new one. You'll find they flare out from the base and wear down on the tip quickly—ending all opportunities for a crisp, sharp line. Your brushes must be in like-new condition. Clean them thoroughly after every use, and when they wear down, buy new ones.

Many artists damage brand-new brushes before they even use them! A new brush has a coat of sizing on it to keep it shaped to a sharp edge. Flexing the bristles to soften that crusty coating unintentionally breaks off the delicate tips of the bristles, leaving a brush with split ends. One manufacturer recommends massaging some oil paint into the bristle tips, and the sizing will disappear without damaging your brush.

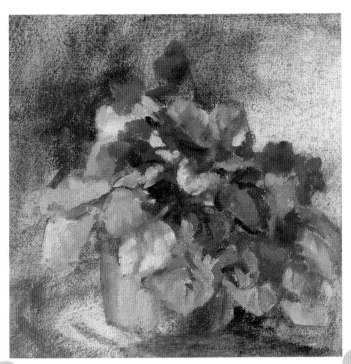

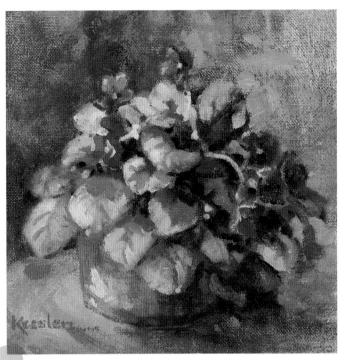

4 Focus on the Dominant Color and Cool Darks

Emphasizing your dominant color (green), continue developing the background, flowerpot and table with a no. 8 filbert. Neutralize the brilliance of the oranges by adding touches of Dioxazine Purple, Permanent Green Light and/or Viridian Green, mixed with white when needed. To create cool, dark accents at the core of the plant, emphasize Dioxazine Purple in your green mixtures using a no. 1 filbert.

5 Add the Details

Use a no. 4 round sable to bring the subject into focus with details, highlights and dark accents. Knowing that sharp edges draw attention, select which edges you want to define and which to leave soft. Define a few negative spaces among the leaves, keeping the paint thin in the shadows. Pile on the paint to create glare for the brightest highlights. With your no. 8 filbert, dash on some opaque paint in the background and on the tabletop to finish your painting. In order to maintain color harmony, develop details with the same colors you have used to this point. If you do add a new color, such as a tint of Lemon Yellow for highlights, repeat it several times in the painting.

Tertiary Color Scheme

Aside from the primary triad and the secondary triad, there remain two more triangular combinations of color you can choose from the color wheel. They are called the tertiary or intermediate triads. These two color schemes are: red-orange, blue-violet and yellow-green, or yellow-orange, red-violet and blue-green. Just as you would with any color scheme, make one color dominant. Use other colors for contrast or mix them to mute.

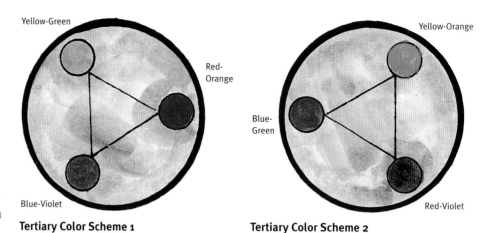

Tertiary Color Scheme 1

Tertiary Color Scheme 2

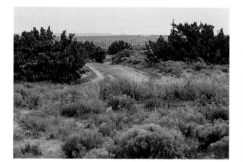

Reference Photo
This desert scene indicates warm hues on an overcast day. You can alter the mood of your painting considerably depending on the color scheme and dominant color you select.

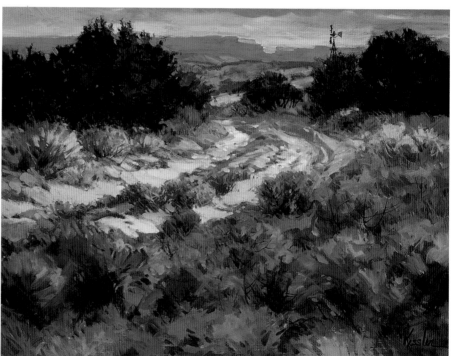

Change a Desert Scene From Warm to Cool
The Steel Harp illustrates the tertiary triad of yellow-orange, red-violet and blue-green. To convey a moody, gray day, I altered the original warm desert hues in the photo by choosing to make this a predominantly cool painting with blue-green as the dominant color. Red-violets tinted with white quietly provide relief from the greens. Yellow-oranges add exciting, warm accents for contrast.

The windmill adds a strong focal point, as it creates a point of contrast (angular among the organic) that rewards the viewer for the trip down this lonely lane. An undertone of a medium-dark value of grayed violet helps create the mood.

THE STEEL HARP • OIL ON LINEN • 18" x 24" (46CM x 61CM)

Analogous Color Scheme

The term *analogous*, meaning similar or comparable, is a good description of this color scheme because it is a family of colors. Start with the head of the family— the one color that you want to dominate in your painting—and add one or even two colors on each side of your dominant color on the color wheel. These colors flow from one to another for a soothingly gentle visual effect.

As close relatives, analogous colors will automatically create a united front— color harmony made easy.

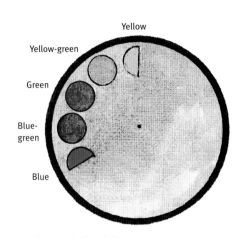

Analogous Color Scheme
Any single color and its adjacent neighbors on the color wheel may be used for this color scheme.

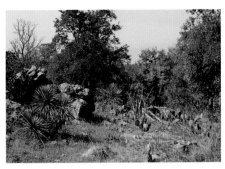

Reference Photo
This scene appealed to me because it isn't all one shade of green as so many landscapes can appear to be. I can easily visualize the finished painting containing many shades of green, from yellowish to bluish. It won't be hard to sneak in a touch of green's complement, red, to add some vitality to the scene.

Working With Analogous Colors
In the field, spring greens are so similar that they can be overwhelming, so exaggerate what you see. Use an analogous color scheme to create a variety of green hues—yellow-greens, greens and blue-greens. You can even extend this family of colors to include yellows and blues. *Gardenfield* emphasizes warm yellow-greens. Practicing repetition with variety to unite colors, I repeated the blues within the foreground flowers and in the distant hills and sky.

GARDENFIELD • OIL ON LINEN • 18" x 24" (46CM x 61CM)

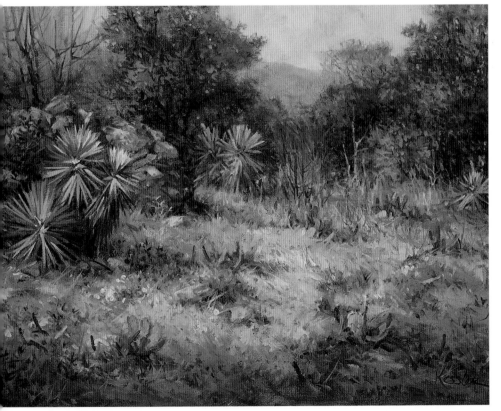

Complementary Color Scheme

Although complements are opposites on the color wheel, together they make great tools for creating color harmony. A color comes to life when placed next to its complement. For instance, if you want red to look extra bright, place its complement, green, beside it. Also, a color that at first appears to be a dull, muddy gray will suddenly spring to life when surrounded by orange, as orange awakens the complementary blue in that gray.

When you want to dramatize something by contrasting colors, you can place complements in sizeable masses side by side. Contrasting opposites will automatically stimulate the eye and draw the viewer's attention to that area of your painting. This is a handy trick to use to create a strong focal point.

When you select a complementary pair as the overall color scheme for a painting, be sure that you emphasize one of the colors and de-emphasize the other.

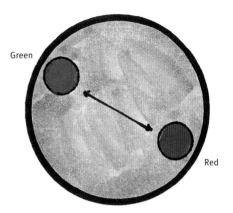

Complementary Color Scheme
Any pair of opposites on the color wheel may be used for this color scheme.

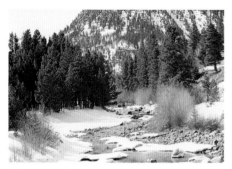

Reference Photo
For this scene, I chose to use the complementary colors green and red. The pine trees and water provide excellent opportunities to establish green as the dominant color. Covering only a small percentage of the canvas with red will create some excitement without competing with the dominant color.

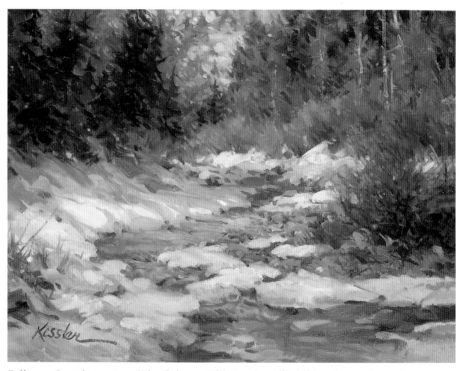

Enliven a Complementary Color Scheme With Touches of Additional Complements
Repeat other complementary pairs here and there throughout your painting to bring more interest to your dominant complements. For example, the light yellow sunlight on the snow in the foreground (Lemon Yellow mixed with white) is dramatized by its complement, lavender (Ultramarine Blue, Quinacridone Red and white). In the distance, pale orange bushes complement blue snow shadows. I combined the reds and greens on my palette for the brown tree trunks. The color harmony might have been lost if I had introduced foreign browns like siennas and umbers into the scene.

TOP OF THE MORNING • OIL ON LINEN • 14" x 18" (36CM x 46CM)

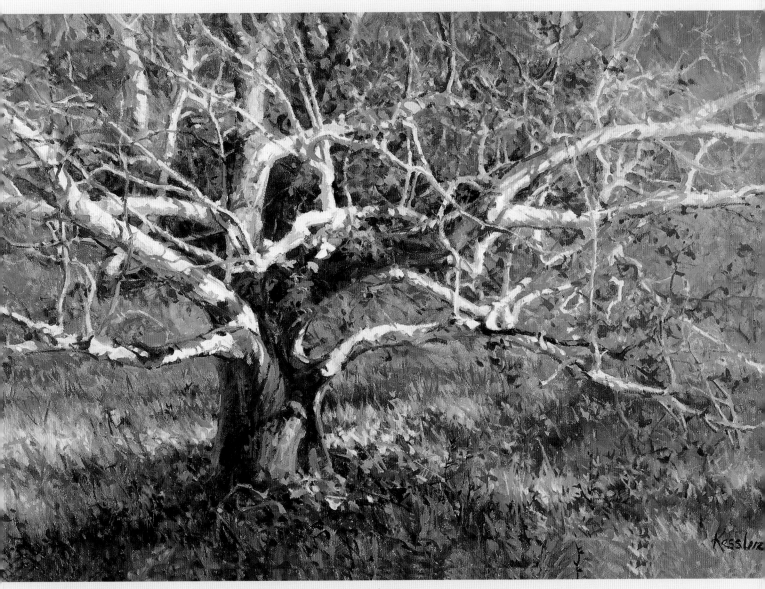

Heighten the Dramatic Contrast of a Scene With Complementary Colors

The bright, warm sunshine reflecting off this bare tree created startling contrasts that attracted me to the scene. One type of contrast appears through the wide value range from almost white to near black, with the lights and halftones dominant. Contrasting opposites from the color wheel, orange and Ultramarine Blue, makes the painting even more dramatic. The painting is dominated by a wide range of oranges—yellow-orange, orange and red-orange. Subtle areas of complementary blues throughout the painting create exciting contrasts. These areas of blue are linked together by blue cast shadows thrown onto the sunny limbs as they crisscross the painting.

THE SYCAMORE • OIL ON LINEN • 24" x 36" (61CM X 91CM)

The Push-Pull Routine

With a touch of the complement you can move a color, and thus an object, from background to foreground or from shadow to sunlight. I call this the "push-pull" routine: push objects back with the cool color of the complementary pair (blue-green sides of the leaves), while pulling other areas forward with the warm color (sunlit red-orange sides). Dramatic highlights, or the areas where the glare of the sunlight obscures the local color of the leaves, are indicated with Cadmium Yellow Medium, the yellow used to mix the red-orange.

If you don't overmix your colors or use pre-mixed colors, pretty "accidents" can happen. When I dropped Quinacridone Red into the background to neutralize the complementary greens, a violet surprise occurred. The red spontaneously mixed with the blue in the blue-green background—a nice relief from the greens.

Without complement (yawn...)

With complement (exciting!)

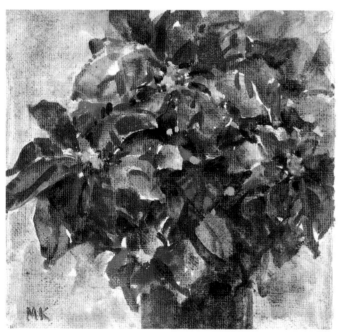

MK

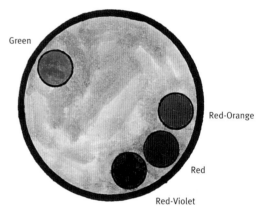

Green

Red-Orange

Red

Red-Violet

Using Analogous Neighbors in a Complementary Color Scheme

If you select red as your dominant color, green then becomes your complement. The colors on either side of red can expand your possibilities while still maintaining a complementary color scheme.

Warms or Cools Should Prevail

Analogous colors generally favor the warm or cool side of the color wheel. In this illustration, warms (reds) prevail. Dominance of one temperature over another enhances color harmony because the warm and cool colors aren't competing with one another for the viewer's attention. You don't want your painting to be half warm and half cool. Half-and-half may be great in your coffee, but you don't want it in your painting!

Using Complements in a Neutral Scene

Do you want to make a predominantly neutral painting that has some energy and life to it? Then think of all the different ways complementary colors can be used: juxtaposed, physically mixed and visually mixed.

The following painting, *Cathedral Lights*, consists predominantly of blue-violets, with some complementary yellow-oranges to emphasize the effects of the sunlight, heightening the luminosity of the scene. This painting also illustrates both the physical and visual blending of those same complements to create a restfully grayed environment.

Reference Photo
When I first saw this mountain range, I was impressed with all of the beautiful hues of gray. What a challenge to paint: to create compatible light and dark, warm and cool, and bright and dull grays without getting muddy colors or resorting to using Payne's Gray or Ivory Black!

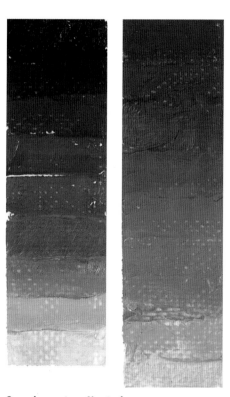

Complementary Neutrals
For this painting I created a series of light-to-dark neutralized cool colors (left) and warm colors (right). I used the same colors in varying amounts for each series: Ultramarine Blue and various oranges made from the yellows and reds on my palette.

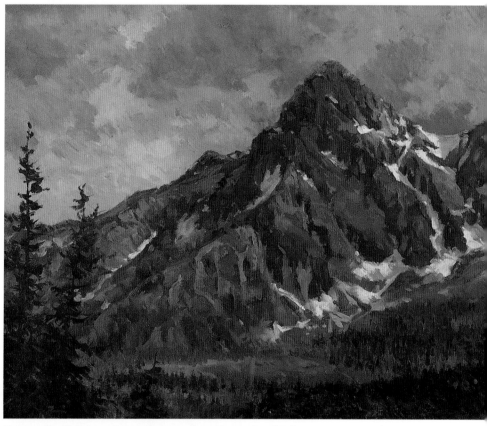

Contrasting Values and Complements for a Strong Focal Point
This painting of an overcast day began with an overall warm-gray wash of Cadmium Red Light mixed with Ultramarine Blue. I placed my darkest darks nearest the focal point, the right side of the mountain, and placed some sunny snow in this area for contrast using white and Cadmium Yellow Medium. To draw more attention to this focal area, I juxtaposed yellow-orange touches against blue-violet ones.

Contrasting various hues of the two complementary colors in both the sky and the landscape provides repetition with variety. I bounced some of the mountain colors into the foreground and sky, making sure to maintain the blue-violet dominance. A couple of bright yellow-orange shapes against the blue-violet ridges where the sunlight changes to shadow make the painting sing.

Cathedral Lights • Oil on linen • 18" x 24" (46cm x 61cm)

Double-Complementary Color Scheme

When using a double-complementary color scheme, you are simply painting with two pairs of complements instead of one. The second pair of complements should appear close to the first pair on the color wheel, using the colors immediately on either side. Be careful not to use the complementary pairs in equal portions. Also remember to emphasize just one of the four colors, keeping the others subservient and using them for accents.

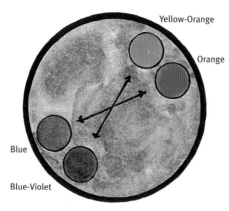

Double-Complementary Color Scheme
This color scheme forms a skinny X on the triadic color wheel. Rotate this X on the wheel to come up with a number of different double-complement options.

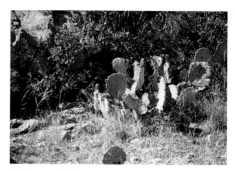

Reference Photo
I was fascinated more with the lighting effects here than the actual subject matter. I selected a color scheme based on this rather than the local greens of the plants.

Juxtaposing Double Complements
In this painting, blue-violet and yellow-orange are the dominant pair of complements, with blue-violet functioning as the dominant color. Touches of orange and blue, close neighbors of the dominant complements, are added in the form of wild grass and blue flowers (called bluebonnets). A thin underpainting of Yellow Ochre, Cadmium Yellow Medium, Cadmium Red and a touch of Phthalo Blue helps to set the tone for the color scheme. These colors were partially blended on the canvas, not on my palette.

SOUTHWEST LIGHT • OIL ON LINEN • 18" X 24" (46CM X 61CM)

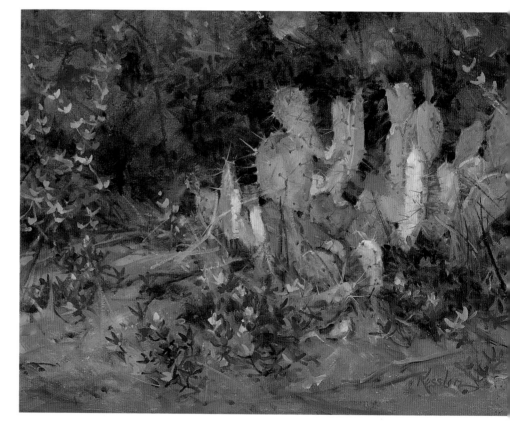

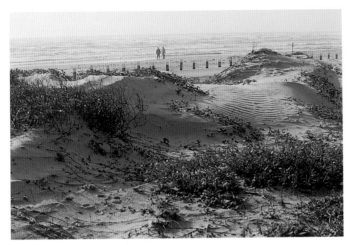

Reference Photo

For this bright, light scene, I used the same set of double complements that I applied in *Southwest Light*. This time I chose to emphasize the warm colors—oranges and yellow-oranges—for the sand, sky and whitewater. I used hues of their complements—blue and blue-violet—for the cool colors throughout the painting.

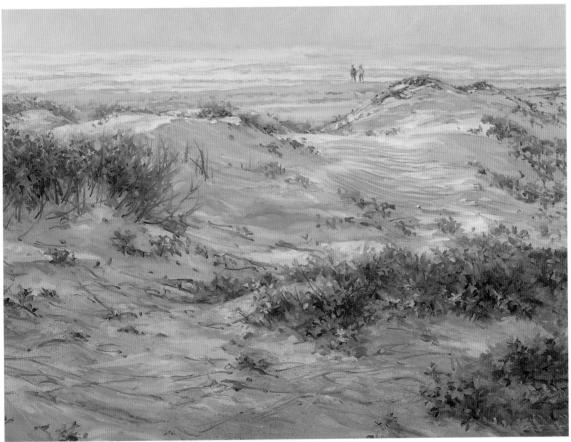

Neutralizing With Double Complements

In *Padre Sands*, I neutralized the oranges and yellow-oranges with their blue and blue-violet complements by using a variation of the broken-color technique. I dotted and dashed, pulled and slashed, modifying the color on my brush after every few strokes. To enliven the wet sand and shadows, I used neutrals mixed directly on the canvas from these complements. For variety, I added some brushstrokes of homemade Yellow Ochre mixed from Cadmium Yellow Medium, Grumbacher Red and a touch of Phthalo Blue.

PADRE SANDS • OIL ON LINEN • 18" x 24" (46CM x 61CM)

Split-Complementary Color Scheme

This is a three-color scheme that calls upon a color's two near-complements instead of its exact complement. Choose any color on the triadic color wheel as your dominant color—say, blue-violet. Instead of using its direct complement, yellow-orange, use its neighbors on either side—the split complements of yellow and orange.

Split complements are more flexible and versatile than direct complements. You can make a subtler color statement with split complements, as they are not as drastically different from the chosen dominant color as direct complements are. For example, the extreme contrast between yellow and its complement, violet, would be reduced to yellow with blue-violet and red-violet. Like regular complements, you may choose to place these colors side by side to draw attention and/or mix them for a variety of harmonious neutrals.

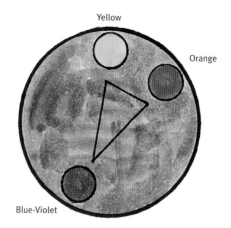

Split-Complementary Color Scheme
Notice that the dominant color and its split complements form a triangle that is not equilateral. Rotate this triangle on your color wheel for other split complements: red with yellow-green and blue-green, and so on.

Reference Photo
To capture the feeling of a cool and damp day in the mountains, I chose blue-violet for my dominant color. Remember, blue-greens are warm because they contain traces of yellow. Conversely, blue-violets, which contain red, are cool—a good choice for a cool painting.

Using Split Complements
This scene was blocked in with a variety of blue-violets (mixtures of Ultramarine Blue, Cadmium Red and Quinacridone Red) before adding touches of the split complements yellow and orange throughout. Orange (mixed from Cadmium Yellow Medium and Cadmium Red) bounces onto the sunlit treetops and into the foreground. Yellow flowers pop the foreground forward. I pushed these split complements a little, juxtaposing yellow and orangish red at the focal point: the two ladies bringing up the rear.

The greens were created with mixtures of Cadmium Yellow Medium and Ultramarine Blue, with a little Lemon Yellow and a tad of Phthalo Blue added to brighten the colors when needed. These bright greens and the bright split-complements help convey the crisp, clean mountain air just after a rain.

STEP IT UP, LADIES • OIL ON LINEN • 18" x 24" (46CM x 61CM)

Monochromatic Color Scheme

A monochromatic color scheme limits you to just one color along with black and white. This scheme doesn't allow for conflicting colors; even the colors of the highlights are the same as the color of the subject you are painting, only lighter. Thus, achieving color harmony is guaranteed, as only one color and its various light and dark values are used.

Using this simplified color plan to make an elementary statement about your subject is fun. Monochromatic paintings are most successful when you use a wide range of values that provide strong lights and darks. Painting with only a few close values can limit the visual impact. So, to avoid a bland look, add light and dark accents just as you would season a dish with salt and pepper. Bring your painting into focus by placing extreme value contrasts near the center of interest.

Monochromatic Color Scheme
The scheme for this painting is based on Ultramarine Blue, modified with Ivory Black and Titanium-Zinc White.

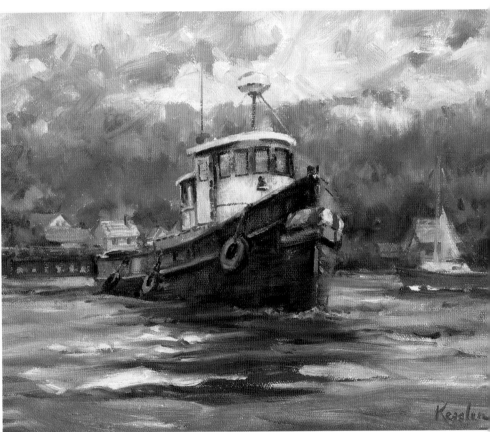

Seaside Blues
To make this scheme work, it's best to use a full range of values. This painting goes from black to dark blue, to medium and light blue, to white. To give the scene depth, the colors progress from relatively warm blue in the foreground to cooler blue-gray and gray as they recede in the distance. The center of interest is the boat, where the largest area of temperature and value contrast occurs.

HEADING OUT • OIL ON COTTON • 9" x 12" (23CM x 30CM)

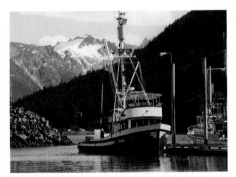

Reference Photo
This scene naturally lends itself to a monochromatic color scheme because it already has a limited color range—the blue-and-white boat in blue water—and the values vary widely. It won't take much imagination to convert this scene to a monochromatic color scheme.

Break the Rules With Discords

Discords are bright jewels—sparkles of color surprises. They are most effective when used for dramatic emphasis near your center of interest.

However, make sure to use discords sparingly. Placing too many discordant marks and scattering them about haphazardly in your painting will distract the viewer from your focal point and create chaos. If you want to lighten and mute discords so that you can use them more extensively, work them in as you develop your painting.

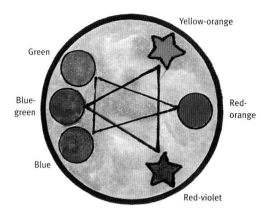

Complementary Color Scheme With Discords
To select a color scheme with discords, start with your chosen dominant color—for example, blue-green. Move directly across the wheel to discover its complement, red-orange. Then, return to your dominant color and draw a triangle that is equal on all sides to locate your two discord colors: yellow-orange and red-violet. In this scheme you can also include the analogous colors of our dominant color: green and blue.

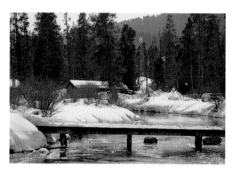

Reference Photo
Blue-greens are a perfect dominant color for this setting—a forest on a pleasant yet cold and damp day. By adding the analogous colors, blue-green's neighbors on either side, I will have a variety of warms and cools. Blue-green's complement and the discords will create excitement.

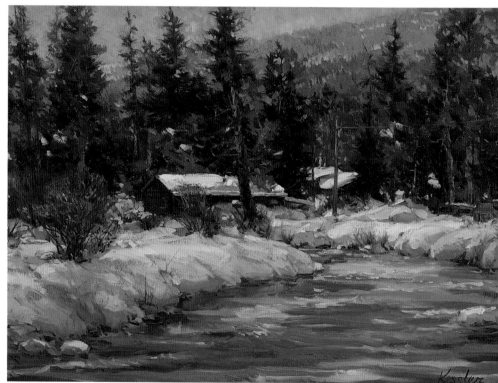

Injecting Life Into a Cold Scene
For this winter scene, I emphasized cool blue-greens while adding complementary red-oranges and the appropriate discords to bring out the warmth and sparkle of the sunlight. Notice the pinkish lavender (a tint of red-violet) discords in the snow shadows near the big cabin, on some tree trunks and in the dormant middle-ground bushes. The yellow-orange discord is most apparent in the foreground bush on the left, the pine foliage on the dominant tree near the center, the shoreline weeds and the storage shed on the far right.

CREEKSIDE EMERALDS • OIL ON LINEN • 18" x 24" (23CM x 30CM)

Placing Discords in a Complementary Color Scheme

Flashing the discords in a color scheme can be great fun. Let's walk through this one step at a time.

MATERIALS

SURFACE
4" x 6" (10cm x 15cm) canvas paper

BRUSHES
Nos. 1 and 3 filbert bristle

No. 1 round bristle

No. 4 round sable

OILS
Cadmium Red Deep (by Grumbacher)

Cadmium Yellow Medium

Grumbacher Red

Lemon Yellow

Phthalo Blue

Quinacridone Red (by Grumbacher)

Titanium-Zinc White

Ultramarine Blue

Yellow Ochre

OTHER
Facial tissues

Gum turpentine and jar

Palette knife (for mixing colors)

Pencil and ruler

Retouch spray (Damar Varnish)

Reference Photo
I was drawn to this attractive design of light that was created by the late-afternoon sun.

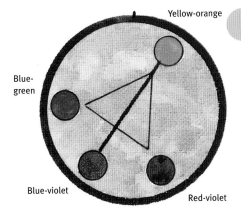

Complementary Color Scheme With Discords
Yellow-orange and its duller relative, Yellow Ochre, are naturals for the dominant color in this warm scene. Complementary blue-violet (Ultramarine Blue) will work for the roof and some shadows. Dashes and dots of the discords, red-violet and blue-green, will make the scene sparkle. To create color harmony, work all of these colors into your local colors, the brown tree trunk and the green foliage.

1 TONE THE CANVAS AND MAKE A DRAWING

After visualizing your finished painting in color, place it on the canvas. Since the reference photo won't need many value changes to capture the design, we'll skip drawing a value plan. Using Yellow Ochre for the overall wash can set the stage for late-afternoon light and, in this case, it will promote the dominant color, yellow-orange. Dilute the ochre with turpentine to tone your canvas. I chose to draw with a pencil rather than a brush since the canvas is so small. Affix pencil markings to the canvas with retouch spray to prevent them from contaminating your next layer of paint.

2 START ESTABLISHING VALUES

Create the light areas by painting these shapes with turpentine on a clean brush and then blotting them with a facial tissue. The ochre tone will lift off, revealing the bare canvas. For warm and cool darks, use various combinations of Yellow Ochre, Quinacridone Red, Ultramarine Blue and white. Using a no. 1 filbert, keep the darks thin so that your shadows will recede on your canvas. We'll lay on thicker paint later as we build toward the lighter values.

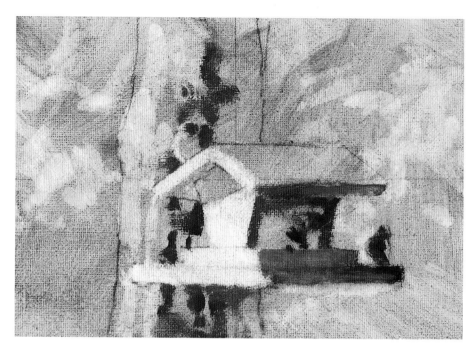

3 BEGIN LAYING IN COLORS

Continue with the no. 1 filbert and the same colors. For variety, use each of these three colors individually or any combination of them, adding white as needed. Modify these mixtures with orange (Cadmium Yellow Medium plus Grumbacher Red) to create warmer darks for the areas in sunlight and to promote the dominant color. A tint of Cadmium Red Deep on the shaded side of the tree trunk indicates reflected light, creating a cylindrical shape.

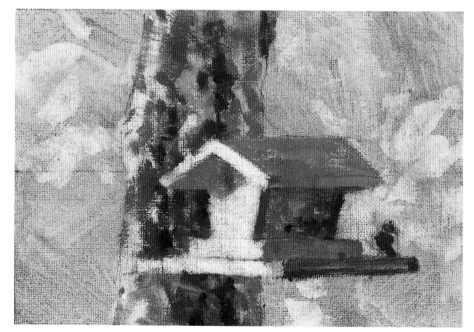

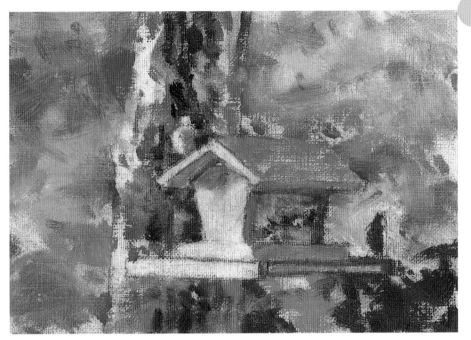

4 BEGIN THE BACKGROUND

Rather than introducing new, foreign greens to your palette, maintain your color harmony by mixing your own greens. Reuse your blue (Ultramarine) and the yellow you used to mix your orange (Cadmium Yellow Medium). Then, as needed, neutralize your mixed green with the two reds you've already used (Quinacridone Red and Cadmium Red Deep), Yellow Ochre and white. (Remember, red and green are complementary colors that neutralize each other when mixed.)

To draw attention to the sunlight on the bird feeder, make the background fairly dark and limit the differences in values. A larger brush, a no. 3 filbert, will help prevent distracting details.

5 ADD THE DETAILS AND DISCORDS

Paint details by bringing the edges into focus. Be selective. Develop sharp lines and contrast the elements of color at your primary center of interest, the sun on the feeder, and the secondary point of interest, the bird in the sun. Minimize the degree of contrast around the bird in shadow. Avoid strong contrasting elements in the corners and along the edges of the canvas. Dash on a few of your two discords, preferably in equal amounts. Tints of blue-green (Phthalo Blue) and red-violet (Quinacridone Red) are scattered about in this painting, particularly around the focal points. Use a no. 1 round bristle and, if needed, a no. 4 round sable for the small details.

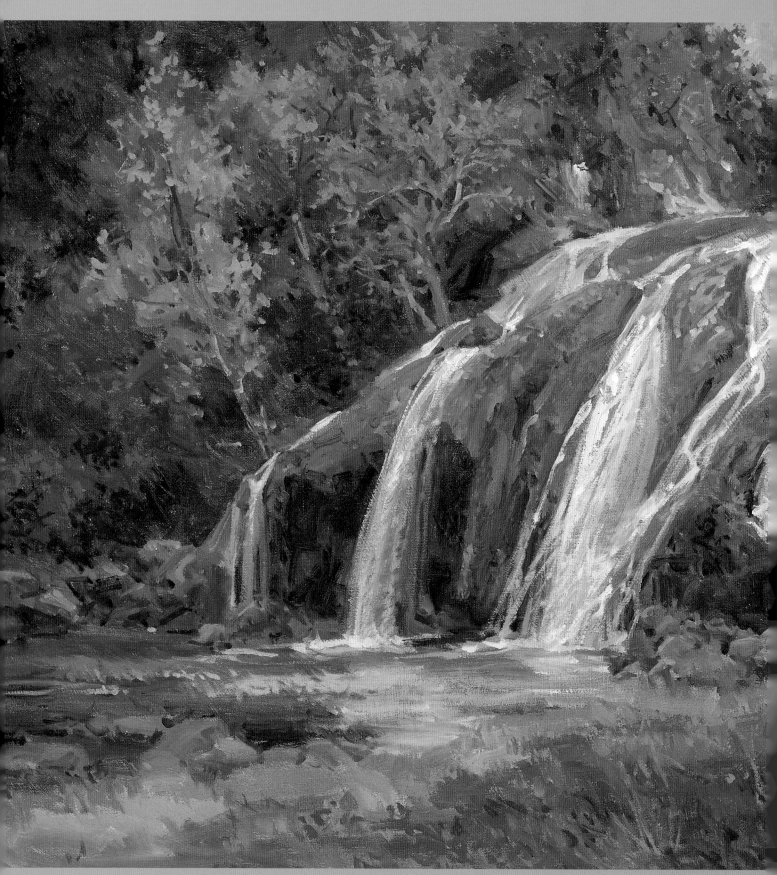

TURNER FALLS AT DUSK • OIL ON LINEN • 18" x 24" (46cm x 61cm)

3
DISCOVERING THE MUNSELL COLOR WHEEL

The triadic color wheel, which you have used to this point in the book, is the most popular wheel in all art-dom. However, it is not the only color wheel available, and it is certainly not the best. Let's look at another option: the Munsell color wheel. Among other benefits, this wheel can help you to achieve more accurate and authentic complements and neutrals in your paintings.

What Is the Munsell Color Wheel?

In 1666, Sir Isaac Newton connected the two ends of his color chart, developing the first color circle. Over one hundred years later, the concept of primary colors evolved and the triadic color wheel was printed. Finding these wheels to be inadequate, Albert Munsell in 1898 created a color sphere that simultaneously shows all the properties of color: value (light/dark), hue (especially warm/cool), and intensity (bright/dull).

Rather than starting with three primary and three secondary colors, as on the traditional triadic wheel, Munsell's color theory starts with five primaries: yellow, red, violet, blue and green. When Munsell's color sphere is simplified to a flat circle (a color wheel), you can see that it contains only ten basic colors instead of the twelve shown on the triadic color wheel. (Munsell did not give yellow-orange and red-orange as much space as the triadic wheel does.)

Munsell's color placement is more precise than you see on the triadic wheel. The complements on the Munsell wheel are more visually accurate than what you can create with the complements on the triadic color wheel. When the bright outer colors on the Munsell wheel are combined with their neighbors as they are pulled to the center, they create purer, more beautiful semineutrals (earth colors) and neutrals (browns and grays).

Any color can be found somewhere on Munsell's color wheel. Yellow Ochre is located in the semineutral section, in from orangish yellow—not with the outer edge's pure colors, nor near the center with the neutrals. Directly across the wheel from ochre is its complement—blue with a hint of violet. It follows that you would use Ultramarine Blue with a touch of red to neutralize ochre.

If, instead, you want to warm and brighten Yellow Ochre, add some sunshine (Cadmium Yellow Medium) to it, as this yellow is a close neighbor of the basic color. You can also see that modifying ochre with yellow-green and/or orange will not cause a major change in its character, that is, mud. In fact, mix these colors (yellow-greens clockwise through red-oranges) together in varying amounts, and you can create your own versions of Yellow Ochre. You are no longer stuck with monotonously monochromatic, commercial Yellow Ochre.

Most browns (siennas and umbers) are considered relatives of orange and red. They are contrasted or muted with their opposites found in the blue family. If you classify each neutralized color you use as one or two of Munsell's primary colors, then you can more easily use the Munsell wheel to see how to modify it. That is, tans and browns should be classified as subtle yellows, neutralized oranges, dull red-oranges, and so on instead of designer names like beige or taupe. Using these latter terms leads you down a dead-end road. Similarly, if you define a semineutral as, for example, a tint of grayed blue-purple, you can see on Munsell's wheel that you would need a yellow for the complement.

Although there is certainly nothing wrong with using commercially mixed neutrals, it sometimes feels as if you are working in the dark with them. Say you squeeze out a little bit of umber, and you want to modify it so that it is cooler. Which blue should you use? Cerulean? Cobalt? Since you don't know which blue went into that tubed brown in the first place, you risk mixing a muddy color. On the other hand, if you mix the ochres, siennas, umbers and grays yourself from your primary colors, you will be able to effectively modify them when you need to.

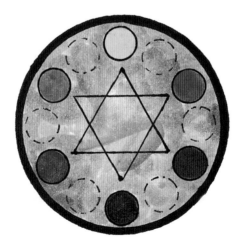

Primaries and Secondaries on the Traditional Triadic Color Wheel
The triadic wheel assumes three primaries (red, yellow and blue) and three secondaries (orange, violet and green).

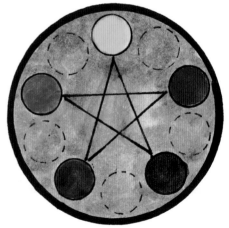

Primaries on the Munsell Color Wheel
Munsell's wheel assumes five primaries: red, yellow, blue, green and violet.

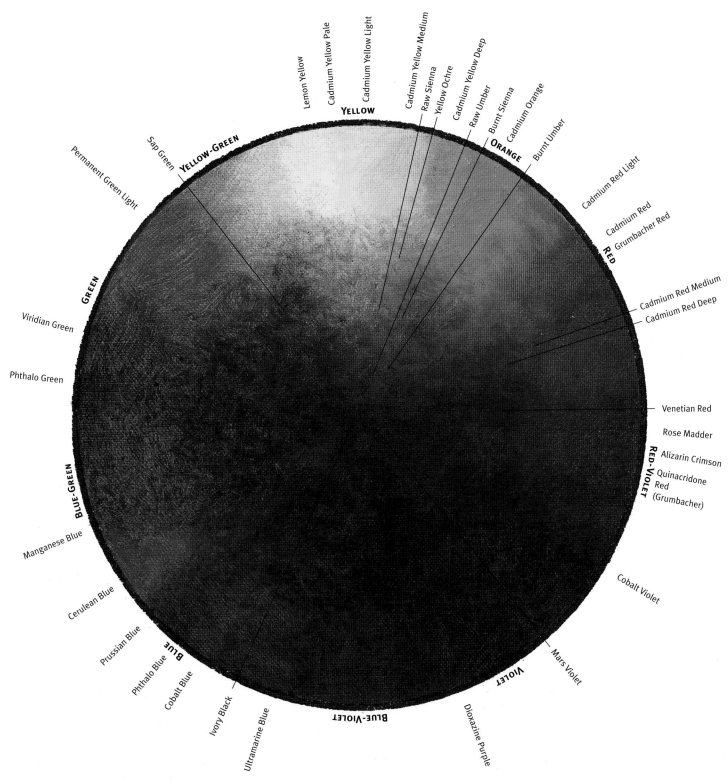

Lemon Yellow
Cadmium Yellow Pale
Cadmium Yellow Light
YELLOW
Cadmium Yellow Medium
Raw Sienna
Yellow Ochre
Cadmium Yellow Deep
Raw Umber
Burnt Sienna
Cadmium Orange
ORANGE
Burnt Umber

Sap Green
YELLOW-GREEN
Permanent Green Light

GREEN
Viridian Green
Phthalo Green

BLUE-GREEN
Manganese Blue
Cerulean Blue
Prussian Blue
Phthalo Blue
BLUE
Cobalt Blue
Ivory Black
Ultramarine Blue

BLUE-VIOLET

Dioxazine Purple
VIOLET
Mars Violet
Cobalt Violet

RED-VIOLET
Quinacridone Red (Grumbacher)
Alizarin Crimson
Rose Madder
Venetian Red

Cadmium Red Deep
Cadmium Red Medium

RED
Grumbacher Red
Cadmium Red
Cadmium Red Light

The Munsell Color Wheel

This version of the Munsell color concept may become your favorite wheel, as all colors are visible. You can find any of your favorite colors on this wheel, even if they are not labeled here. You can locate a color by placing a sample of your paint on the edge of a piece of paper and then hunting for where that color lies on the wheel. Observe its relationship to colors around it and across the wheel in both directions. Notice the colorful neutrals you track through on your way.

How to Use the Munsell Wheel

All the color schemes you learned in chapter two work even better on the Munsell color wheel than on the traditional triadic wheel. Since the complements are a little different on Munsell's wheel, the color mixtures are slightly different, too. On this wheel, the complement of yellow is blue-violet, not violet as you see on a triadic color wheel. This modification mixes prettier neutrals and attracts more attention when it comes to juxtaposing colors. Munsell's influence is more likely to lead to the beautiful paintings you visualize.

Make yourself a stencil to use on Munsell's full-color wheel. Photocopy (in color or black and white) or trace the pattern on the opposite page. Remove the four cut-out areas, and lay this stencil over Munsell's full-color wheel on page 53. Rotate it until your dominant color is centered on the mark at the top-center of the stencil. The cutouts do the rest for you. Before your very eyes is your analogous color scheme, complete with the complement and discords.

With the stencil overlay in place, look near the center of the wheel at all those great semineutrals and neutrals that will work harmoniously with your color scheme. If you don't like to mix your own neutrals, you can find your favorite commercial colors on this wheel. Then look at the neighboring colors that you can use to modify them and identify their complements so you can mute the intensity of them even more.

Notice the sizes of the holes left by the four cutouts. They suggest proportionately how much of each color you will want to use in your painting. The dominant color, its adjacent colors and their neutrals obviously get the biggest portion of your canvas. (For some paintings you may decide to make this cutout narrower—reducing this color span a little.) As you can see, the discords are small and equal in size—just like you will want to use them in your paintings.

You may increase the two discords and/or the complementary portions shown on the analogous stencil if you cut their intensity by adding white to tint them or by neutralizing them. For example, you could use blue-green as your dominant color and bright red as your complement to paint a blue-green plant with just a few red flowers on it—as the size of the complementary shape on the stencil indicates. Or you could paint a similar blue-green plant with a number of large pink flowers on it—enlarging the complement's portion of your canvas since you lightened that intense red. This same principle of cutting the intensity when enlarging the portion works for discords, too—just keep them equal in size.

Balance is the name of the game here. If you paint a picture placing your colors on the canvas in roughly the same proportions shown on this stencil, you are well on your way to achieving good color harmony.

PRINTER'S COLORS

The basic triadic wheel is a good place to start your color journey, but for years publishers have used a spin-off of the Munsell wheel to print colored pictures. They knew yellow, red, and blue did not reproduce colors accurately, so they used yellow, magenta (purplish red), and cyan (blue-green) instead. If you place an equilateral triangle on the Munsell wheel pointing one tip to yellow, you will see that the printer's three colors are equal distances apart—just like red, yellow and blue are on the triadic color wheel.

Neither the triadic nor the Munsell wheel is right or wrong; they are simply different from each other. They are both conceptual tools that help you with color relationships. No matter which of these wheels you choose, you can create beautifully harmonious paintings by using them to to find traditional color schemes.

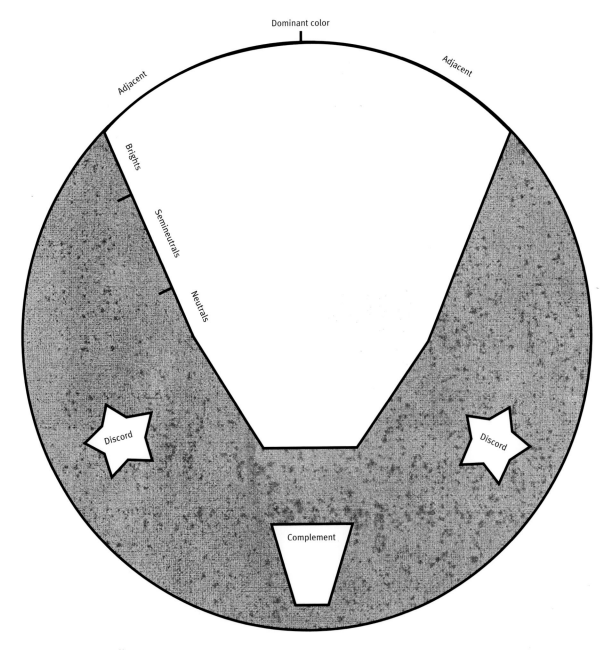

Analogous Color Scheme Stencil

Photocopy this stencil and overlay it on the Munsell color wheel on page 53. Rotate this stencil to find an analogous color scheme, including the appropriate complement and discords, on any area of the wheel.

Putting the Munsell Wheel Into Action

The triadic color wheel provides the best way for you to get acquainted with basic color principles: *Red and yellow make orange. Opposites on the color wheel are complements. Complements and triadic colors make neutrals when mixed together.* Now that you recognize and understand the basic color wheel concepts, you can begin using these same principles on Munsell's full-color wheel—especially when you are working with complements or with an analogous color scheme.

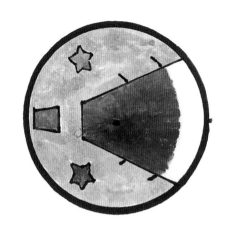

Analogous Color Scheme for *Water Colors*
Unlike the triadic color wheel, Munsell's full-color wheel can easily handle bright and dull colors. Just pretend Munsell's wheel has the bright colors covered up. Then lay your analogous stencil on it. Center, from left to right, your dominant color in the largest cut-out section of the stencil. The rest of your color scheme is immediately revealed.

You will find the dominant color for *Water Colors*, an earthy red, on the cool side of red in the semineutral section. Just as you learned on the triadic color wheel, the complement is directly across the wheel. Using your analogous color scheme stencil, you can see the colors adjacent to your dominant color and locate your discords.

● ● ● ●
TEN REASONS TO USE MUNSELL'S COLOR WHEEL

1. It serves as a functional full-color wheel, showing semineutrals and neutrals.

2. It adapts to all traditional triadic color schemes.

3. It simplifies the use of complex color schemes.

4. It indicates complementary colors that are truer to nature.

5. When you use a stencil overlay, it balances color proportions, revealing how much of each color to use.

6. It takes the guesswork out of mixing and modifying colors.

7. It reveals the colors contained in commercial semineutrals and neutrals.

8. It reduces the risk of muddy colors.

9. It saves time.

10. It challenges you to use colors in a logical manner.

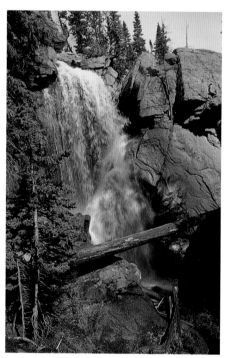

Reference Photo
To convey the subdued mood of this scene, you wouldn't want to use the pure, bright colors on the outer edge of the Munsell color wheel.

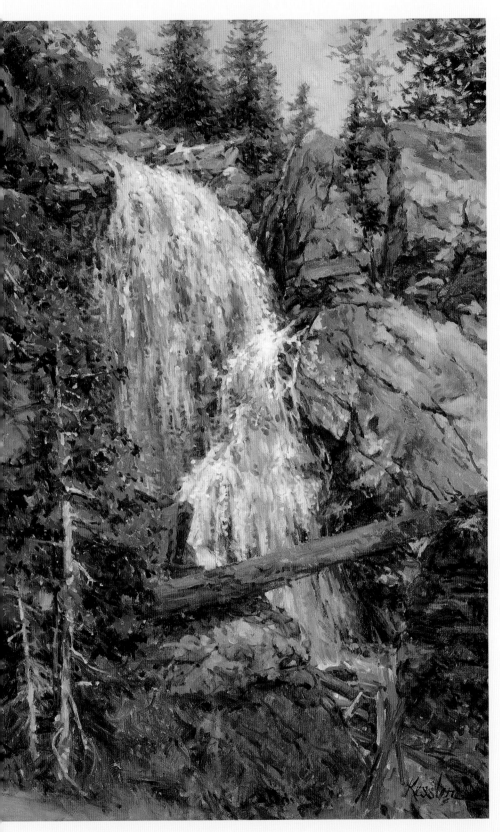

Finished Painting

I began by toning the white canvas with an overall wash of neutralized red in medium-light values—Quinacridone Red with orange and a touch of Phthalo Blue—to indicate the color theme. I painted the rocks using a variety of tints of both the warm and cool semineutrals revealed by my analogous color scheme stencil. I repeated these rock colors in the trees. I also bounced the rock's complement (the greenish blue-green color of the trees) into the rocks. The falling water reflects these same colors. You can also combine (on the canvas) some tints of these colors to use for your sky, completing your harmonious color scheme.

In this muted painting, it is important to use the discords at full intensity. Bright jewels added in equal amounts as you finish the details will bring your neutrals to life. I placed some discordant purplish blues in the shadow areas of the falling water, and yellow-greens in the foreground (left) tree and the sunlit tree in the upper right.

Water Colors • Oil on linen • 30" x 20" (76cm x 51cm)

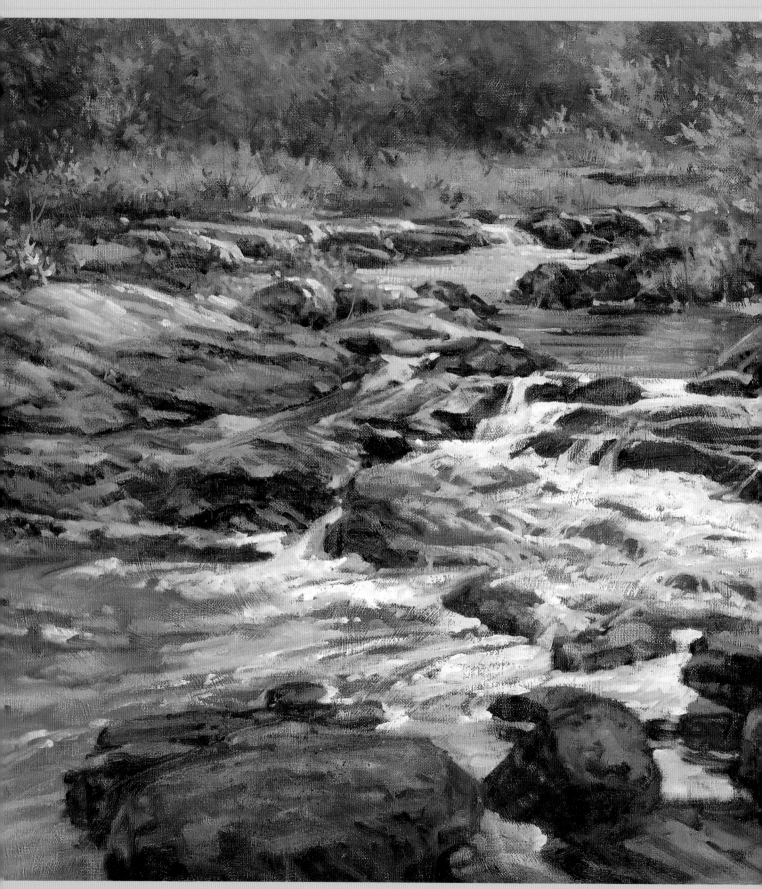

RUNNING BROOK • OIL ON LINEN • 18" x 24" (46CM x 61CM)

Kessler

4
MASTERING THE CONTRASTS OF COLOR

Contrast is integral to building color harmony. Knowing how to contrast the different elements of color—value (light against dark), temperature (warm against cool) and intensity (bright against dull)—prevents boring, flat-looking paintings. Varying contrast allows you to draw attention to your focal point and play down distractions. You can even control the speed at which the viewer's eye arrives at that focal point.

Contrast creates interest and energizes your painting, but it must be controlled. Erratic, random contrasts can lead to chaos. The key to achieving color harmony as you manipulate the value, temperature and intensity of colors is to work within the boundaries of a traditional color scheme, and maintain the dominance of just one color chosen from that scheme.

Contrast of Value

Value is an important element in color harmony because it attracts attention before color stirs your emotions. Many paintings fail because the artist reads the values of the colors incorrectly. A painting may be very colorful, but disorganized light and dark values lead to a disjointed, chaotic and ultimately unsuccessful design.

To create exciting, energetic scenes, use a full range of values, from very light to very dark. Full-value paintings scream for attention because our eyes are instantly attracted to the contrasts of light and dark.

After working out a preliminary value sketch in pencil, it's best to transfer your value plan to the canvas before applying colors and thick paint. Create a thin underpainting that just hints at the colors you will use. After you have plotted your values on the canvas, add colors reproducing those values. Working in this way helps to ensure that your value design will not be lost as you build the painting.

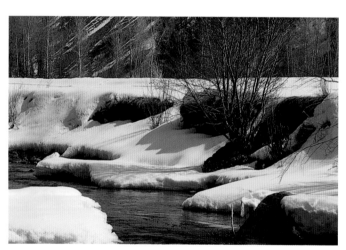

Reference Photo
A sunny snow scene and the full-value range make great partners—sparkling and crisp. Both are dramatic.

Value Plan
Consider that even in full-value paintings, you still need to decide which value will dominate—light or dark. In this predominantly light setting, connect the dark shapes so that they lead the eye back and forth through your painting. At times, just a narrow, fairly dark line will make the connection. Interrupt this Z-shape composition with the vertical growth of some bushes to slow down the viewer's eye as it travels through the scene.

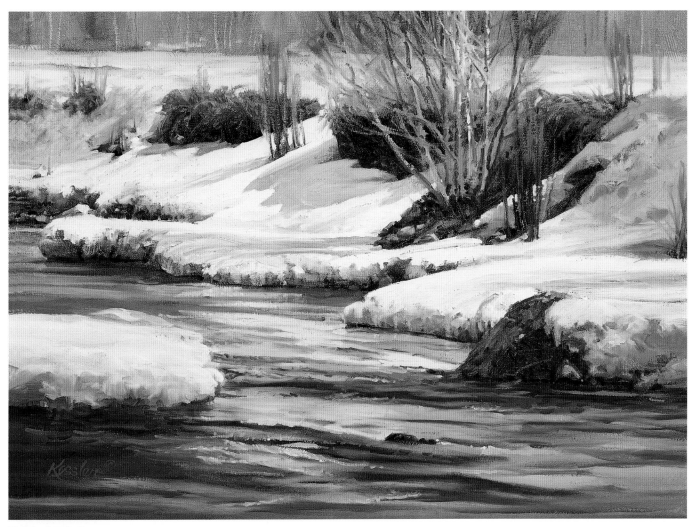

Finished Painting

For the painting, I toned the canvas with a middle to middle-light value of Yellow Ochre mixed with a little Dioxazine Purple. This made it easy to lighten the sunny snow areas by lifting out some of this tone using a brush loaded with clean turpentine, then blotting the area with a facial tissue. Notice that as colors recede into the distance, values become less distinguishable; that is, lights (the snow) grow darker and darks (the water and weeds) become lighter.

FIRST THAW • OIL ON LINEN • 18" x 24" (46CM x 61CM)

VALUE CHECK

You can quickly check the value contrasts in your paintings for accuracy by squinting your eyes. This will eliminate enough light to reveal your light and dark patterns without confusing you with colors. A piece of transparent red plastic (preferably orangish red) makes an excellent color filter for comparing values. (Report covers from an office supply or photocopy store work well for this.) Making a black-and-white photocopy of a colored photograph of your painting works too. If what you see looks chaotic, chances are you lost your originally strong value design when you overlaid it with color of the wrong value.

High Key vs. Low Key

For some paintings you may want to limit your values to one end of the value scale for relatively light or relatively dark paintings. A limited value scheme can greatly affect the mood of your painting as well as the design. A high-key value scheme, using primarily middle to light values, could lend to a lighthearted, delicate or sensitive mood. Low-key paintings, using mostly middle to dark values, can make a scene seem cozy or mysterious. Try a few different value schemes for the same subject to determine which fits best for the mood or emotion you are aiming for.

High-Key Value Scheme

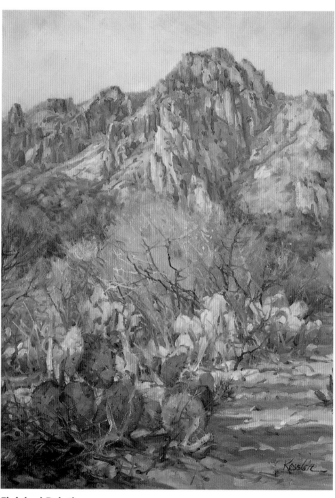

Finished Painting
A high-key scheme is just the thing for this desert scene. The bleaching hot sun is easily conveyed with light colors and limited value changes. To avoid a faded, anemic look in predominantly light paintings, add a few touches of bold color for contrast with one or both of the other two properties of color—temperature and intensity. For example, notice how I added bright blue-green to the bottom of this painting.

NATURE'S SANCTUARY • OIL ON LINEN • 24" x 18" (61CM x 46CM)

Low-Key Value Scheme

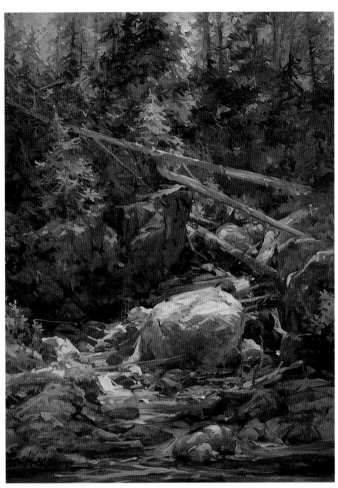

Finished Painting
The low-key scheme for *Gorgeous Gorge* sets the mood for a cool, quiet retreat. When beginning a low-key painting such as this, tone your canvas with a middle-value wash rather than the light tone you would use for a high-key painting.

GORGEOUS GORGE • OIL ON LINEN • 24" x 18" (61CM x 46CM)

Contrast of Color Temperature

Hot peppers and ice cream! How's that for temperature extremes on your palate? Such a dramatic contrast is sure to make your taste buds stand up and take notice every time. Contrasting color temperatures on your *palette* works in a similar way—it will make your viewer stand up and take notice of your painting.

In the simplest of examples, you would probably paint a sunny scene using predominantly warm colors, and a snowy scene with mostly cool colors. However, your color choices don't always have to be this predictable. The most important thing to remember is to emphasize one temperature or the other in any given painting. Indecision can result in a half-warm/half-cool painting, and can create unappealing tension in your work.

Temperature dominance will help unify your colors and express whatever mood you want in your painting. Many artists, especially extroverts, favor warm paintings, as they tend to generate feelings of excitement and energy. I usually call upon warm colors to convey a lively mood and cool colors for a serene one.

Decide what tone you want your painting to have (warm or cool, light or dark), and apply a thin wash of it on your canvas before you begin painting. This wash will show through in areas of the finished painting, uniting all the colors and perpetuating the dominant temperature and value.

A Predominantly Warm Approach
This arid landscape was bathed in the reds of evening light. I toned the canvas with an overall wash of Cadmium Red Deep to set the stage. Upon close inspection, this tone is visible in the finished painting, bringing unity to the secondary color scheme I chose. A warm, earthy orange dominates this triad of orange, violet and green.

THE HILLCOUNTRY AT DUSK • OIL ON COTTON • 12" x 16" (30CM x 41CM)

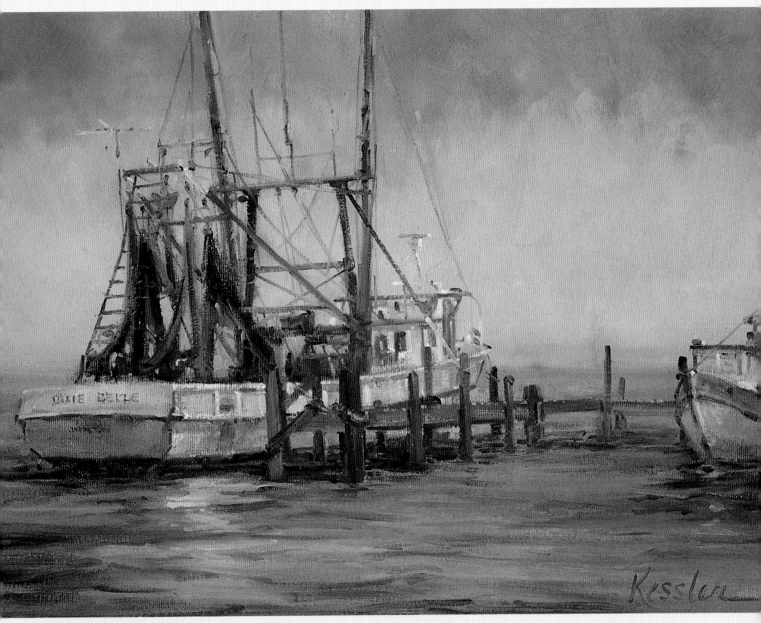

A Predominantly Cool Approach

Even though the evening light is a warm color here, the nature of the scene calls for cools to dominate. I decided on the primary color scheme, emphasizing blue. I toned the canvas with marbleized strokes of Yellow Ochre, Quinacridone Red and Ultramarine Blue. When the sky and water were ready for thick paint to be applied, I repeated tints of these same colors, adding tints of orange and Phthalo Blue for the sunny, warm areas.

THE DIXIE BELLE • OIL ON COTTON • 12" x 16" (30CM X 41CM)

Contrasting Temperatures Within a Painting

Include both warm and cool contrasts within each painting. Adding a few cools to a mostly warm painting (or vice-versa) dramatizes the dominant color. This addition of contrasting color offers pleasurable relief for the eye.

You can also vary the temperature to convey the qualities of such things as sunlight or shade, dryness or wetness, and activity or calm, just to name a few. Be sure to apply these varying temperatures in the appropriate places.

Wrong
Inexperienced painters often make the mistake of painting the dark openings on the sunlit side of a building with cool blues, grays, or worse—black.

Right
As a rule, place warm darks in the sunlit areas and cool darks in the shade. In this example, save the cool colors for the shaded side of the building. Use warms from your color scheme for those dark openings or shadows on the sunlit side. Remember, don't use warm colors on the shaded side of the building unless you wish to convey an interior source of light.

Reference Photo

If you paint from personal experiences, most of the time your memory can help you easily select an appropriate color scheme. This canyon was stifling hot! Red-orange, though cooler than radiating yellow, is still warm enough to convey intense heat. Some cool complements will emphasize this warmth.

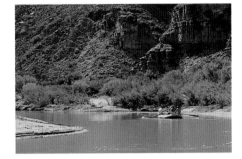

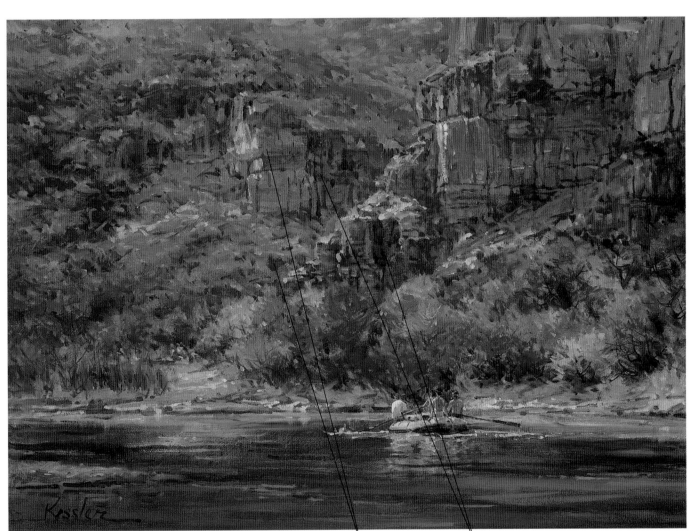

Contrast Warm Darks With Cool Darks

I painted the shaded side of the sunlit rocks with warm reddish browns. I contrasted those hues with cool darks in the shadow to the right. The temperature change is subtle, but when combined with a value step from light toward dark, it is effective.

Warm darks Cool darks

WHAT WE DID LAST SUMMER • OIL ON LINEN • 18" x 24" (46CM x 61CM)

Emphasizing Warm Colors

A warm painting that contains *no* cool colors at all lacks the drama contrast creates. For this scene, we'll use a predominantly warm color scheme with some cool accents.

Color Scheme
The sandy colors visualized for this scene are a great match for this color scheme on the Munsell wheel. Yellow Ochre will be the dominant color, complemented by cool blue-violet. Some yellow-greens, yellows, oranges and the local neutrals (Yellow Ochre's neighbors) will adapt well to this predominantly warm theme. Note the discords: red-violet and blue-green.

Reference Photo
What attracted me to this scene was the protected, sunny cove. Predominantly warm, light colors would work best for this. Sandy semi-neutral colors (ochres) will dominate. The inner energy of this awesome location (Bermuda) could be expressed with a full range of values.

Light source ➡

Value Plan
In this small sketch, I began by deciding how to divide the canvas. Will the painting focus on rocks and water, waves and the beach, or the people? To give equal billing to all of these would create confusion, so I decided to emphasize the calm, protective nature of the massive rock barrier. A visual path starting from the lower-left corner leads the viewer's eye from left to right along the water line to the focal point: the two ladies. The large boulder points you back into the picture and eventually out to sea, forming an S-shaped composition. The people are placed appropriately off-center, but not too close to the edges or corners of the picture.

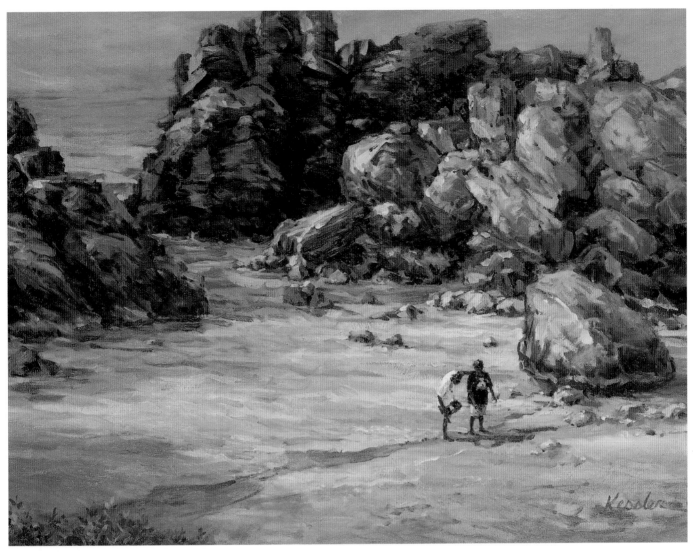

Finished Painting

An overall wash of Yellow Ochre thinned with turpentine immediately set the tone for the lighting conditions of the day: sunny and warm. I blocked in the color scheme with warm colors (a mix of Yellow Ochre and Cadmium Red Deep) that were slightly darker and cooler than the overall wash. For the lightest values, I either left the tonal wash exposed or lifted out some of the tone with turpentine. Darker values were applied with a mixture of Dioxazine Purple and Yellow Ochre. Then I overlaid this underpainting with colors from my analogous color scheme, reproducing the values in thick, colorful paint. To draw attention to the focal point, I used the complement of ochre, blue-violet, for the shirt on one of the figures.

Two cool discords, Viridian Green and Quinacridone Red mixed with Dioxazine Purple, add sparkle to the painting. These bright colors were dotted and dashed directly on the canvas near the focal point. You can see the lively effect of the more subdued discords used in the blue-greens of the foreground bushes, in the water, and on the little tree in the rocks. Tints of red-violet can be found in the wet sand, the rocks in the shadows, and on the horizon.

COASTAL COVER • OIL ON LINEN • 18" x 24" (46CM X 61CM)

DEALING WITH INACCURATE HUES

If some of your colors become the wrong hue, either too warm or too cool, scrape just that area off. After scraping, wash the remnants of the paint off with turpentine and blot dry, then repaint the area. If the whole painting is either too cool or too warm, wait until the paint dries. Use retouch varnish and lay warm (or cool) colors over some of the undesirably cool (or warm) areas. Reworking a dried painting ensures that the new layer of paint won't combine with the previous layer, and you'll avoid mud. Varnish secures the new layer of paint, helping it stick to the dry paint, and ensures that the new, wet colors and the dried colors match.

Emphasizing Cool Colors

When you want a predominantly cool painting, don't start with your coolest colors. Keep your early steps a little warmer than you want the finished painting, and cool things as you work. This approach prevents the premature graying of your colors.

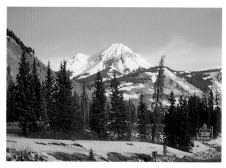

Reference Photo
Keep your camera loaded and ready to use at the drop of a hat. This slide was taken from the window of a moving bus headed for the ski slopes. Its quality is good enough for a quick study of this sunny yet cool winter scene.

Color Scheme
This analogous color scheme naturally sets up a cool color theme. Blue-violet is dominant and yellow-orange is the complement. Yellow-green and red are the optional discords.

Light source

Value Plan
Visualize your painting and lay it out in a limited number of shades of black and white. Make your sketch the same portions as the canvas you want to use. Determine the location of your light source and your focal point, the mountain peak. In this painting I contrasted horizontal bands of lights and darks in varying widths to develop the design.

Finished Painting

First I toned the canvas with a violet wash of Quinacridone Red and Cadmium Red cooled with a touch of Phthalo Blue. I was careful not to make it so dark and cool that I wouldn't be able to easily cover areas of it with warm lights. I then began developing the values by blocking in the darks using warm browns (various mixtures of Lemon Yellow, Cadmium Red Deep and a touch of Phthalo Blue) and lifting out the tonal wash in the light areas, such as the sunny snow on the mountain peaks.

Emphasizing the cools, I used a variety of greens in the foreground trees. For the snow, I began at the sunny mountain peak with a yellowish white and cooled it as I worked my way down to the valley floor. Shadows on the snow are tints of warm and cool blue-violets in the foreground that cool to blues and become lighter as they step into the distance. Complementary yellow-oranges for the autumn trees excite the eye. I allowed the underpainting to show through in places to tie all the colors together. Major portions of the sky were painted with the same color mixtures used for the snow.

A Peak in Time • Oil on linen • 18" x 24" (46cm x 61cm)

Contrast of Intensity

Contrasting bright and dull colors is an important factor in creating expressive paintings. Bright, intense colors bring instant excitement. To make bright colors in your paintings vibrate even more, juxtapose them with a few dull neutrals. Keep in mind when placing your colors that intense ones come forward and dull ones appear to recede.

Just as with temperature and value, this particular contrast must have a dominance. Predominantly bright paintings cry out for attention. They are also easier to create, since you can start with bright tube colors and mute them as much as you want as you develop the painting.

Conversely, less-intense colors work well for quiet, meditative themes. Combine neutralized colors with relaxed horizontal lines, simple shapes, close values and perhaps an analogous color scheme, and you have all the tools you need to create a restful scene.

Using Brights to Showcase the Colors of Autumn
Bright colors can be busy and exciting, especially when you contrast them with muted hues. Using the secondary color scheme with artistic license, I made these golden autumn trees appear intensely bright by juxtaposing them with violets and greens. The orangish light radiating throughout the painting unites this triad of colors. The vibrant atmosphere is also portrayed through the use of the full range of values, occasional dashes of the complements (red, yellow and blue), selected sharp edges and restful horizontal lines interrupted with strong verticals.

AUTUMN DANCE • OIL ON LINEN • 18" x 24" (46CM x 61CM)

Neutralizing Brights for a Subdued Scene

Dull, neutralized colors automatically give the impression of soft edges, which work perfectly for this dreamy, romantic scene. To promote the quiet theme, I used a limited value range (mostly darks) and restful horizontal lines. Contrasting elements were kept to a minimum, as quick color changes would break the tranquility of the scene. For the color scheme, cool Viridian Green is the dominant color, and complementary red is included only in very muted hues.

Don't break the mood of a subdued painting by adding extreme light or bright accents during the last phase. I was careful not to make the patch of sunlight on the water and rocks near the center too bright. Also, subdue or limit the use of dramatic discord colors. Save them for bright paintings.

ROCK CREEK • OIL ON LINEN • 14" x 18" (36CM x 46CM)

Contrasts: Putting It All Together

Consider all the contrasts available to you—not just the ones related to color—as you set out to do each painting. In addition to contrasts of light and dark, warm and cool, and bright and dull, here are some other contrasts to think about:

Line
- vertical and horizontal
- thick and thin
- straight and curved
- continuous and broken

Shape
- large and small
- simple and complex
- geometric and organic
- hard and soft edges

Paint
- thick and thin
- opaque and transparent

Brushwork
- broad and delicate

When working with contrast in your painting, follow these guidelines to make sure it is used most effectively:

- Exaggerate contrasts nearest to your focal point. This area should draw the most attention.

- Subdue contrasting elements in areas that might distract the eye from your focal point. Contrast in other areas is OK, but don't let it steal the show.

- If your painting has a lot of contrast, make sure to repeat some familiar things for relief (a color, a shape, etc.). Exercise repetition with variety.

Let's look at the use of contrast for two very different paintings.

Contrasting this large tree and the mammoth mountains with a small human figure conveys the vulnerability of mankind.

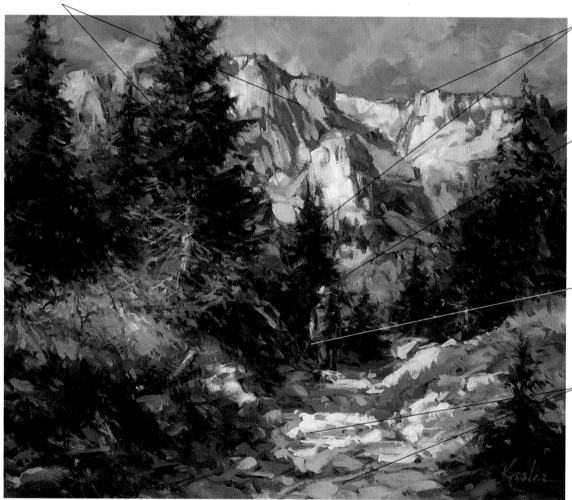

The strong vertical lines of the ranger and the trees break the more restful horizontal lines naturally found in landscapes—the horizon line, the top of the mountain range, and cast shadows.

To create excitement, juxtapose the violet background with its complement yellow (the ranger's hat). Light against dark, warm against cool, bright against dull, and the placement of a human face in nature also call the viewer to this focal point.

This First Aid kit places a dash of complementary red against this ranger's green uniform. Red is also subtly repeated here and there throughout the painting.

Thick paint glistens in the sunny areas when contrasted with the thinly painted shadows. These lost-and-found edges also guide the viewer down the path toward the center of interest.

RANGER BOB • OIL ON LINEN • 20" x 24" (51CM x 61CM)

This vertical bush stops the viewer's eye from leaving the painting. But restful horizontal lines dominate, continuing the moody theme.

Cool colors are kept to a minimum to avoid contrast that would interrupt the emotional theme. The warm glow of the painting enhances nostalgic feelings.

Contrasting large and small, the car and the oil drum, makes a good partnership.

HERO OF THE PAST • OIL ON LINEN • 12" x 24" (30cm x 61cm)

Bright colors are limited to the center foreground and center of interest to keep the viewer from being distracted by the background. Note that even the lower corners of the canvas have been muted.

Sharply contrasting values are restricted to the focal point, the grill on the front end of the car. Ninety percent of the painting is done in a limited range of values to convey a quiet mood.

WAITING • Oil on linen • 20" x 30" (51cm x 76cm)

5

HOW LIGHT AND ATMOSPHERE AFFECT COLOR

Whether you paint still lifes, portraits or landscapes,

color relationships can help create the illusion of form

and depth. All you need to understand is how light and

atmospheric conditions affect the local colors of a

scene. By manipulating color correctly, you can change

a circle into a ball; you can make trees appear to be

right in front of you or several miles away. It's not magic!

With practice, you too can learn the tricks of the trade.

How Light Affects Local Color

The amount and type of light that falls on an object always affects its true color, or *local color*. The local color of an object is simply a starting point. The colors of light are constantly changing depending on the time of day, affecting the local colors of everything we see.

Once you are familiar with how light changes color throughout the day, you can modify the local colors in your painting, conveying any time of day that you desire to portray. For example, if you wanted to paint a green tree in early morning light, you would modify the green with tones of yellow—the color of morning light. In many situations, you can paint the color of light and use just enough local color—in this case, green— to indicate the true color of the subject.

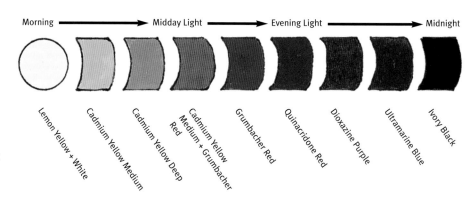

The Colors of Light
On a clear day, natural light washes the landscape with a variety of colors ranging from warms in the morning to cools in the evening, modifying the local colors of everything that you see. To indicate time of day, use these colors of the light to adjust your local colors.

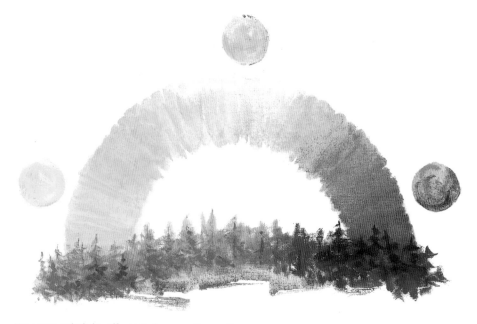

How Natural Light Affects Color on a Sunny Day
Time of day tells us the direction of the light and often its intensity. There is a noticeable difference between light at noon and at just past five o'clock. On sunny days, the color of the light changes many times. Early morning light is quite yellow and looks clear and refreshing. As the clock moves toward noon, the light takes on a Yellow Ochre tone—light in value because colors are bleached out by the intense sun overhead. As afternoon light develops, the Yellow Ochre darkens and then progressively changes to orange, orange-red and then to red as sunset approaches. You can see the effect of the changing light on the green pine trees painted in this illustration.

Adjusting Greens for Different Times of Day

Green is often a hard color for students to use; many times they end up with garish, unnatural hues. For natural-looking hues, modify your greens with the color of the light that you see at a specific time of day. Try these additions:

Sunrise: add Lemon Yellow

Morning light: add Cadmium Yellow Medium and/or Cadmium Yellow Deep

Noon and afternoon: add Yellow Ochre and oranges

Sunset: add red-oranges, Grumbacher Red and Quinacridone Red

Twilight: add reds and Cadmium Red Deep

Dusk: add Cadmium Red Deep, Dioxazine Purple and Ultramarine Blue

Look at how the changing colors of light influence the local color of these similar green trees.

Sunrise
For early morning scenes, start with a Lemon Yellow wash on your canvas. This dominant color will unite all the colors in your painting. If you dislike the intensity of this hue, add a touch of Yellow Ochre to tone it down. Be consistent: keep your greens warm and sunny too. This will enhance the emotional impact of your painting.

Noon
Yellow Ochre is an ideal tone for most noontime scenes. The value of this color should be fairly light because the overhead light washes out your darks and reduces the intensity of bright colors. Indicate your light source by painting the foliage at the top of the tree both warmer and lighter than at the bottom.

Sunset
Orange, red and red-purple hues set the scene for sunset paintings. Tone your canvas with Cadmium Red Light. The closer it is to dusk, the cooler you want to make your wash. Continue the evening light theme by modifying your greens with those same sunset hues. Avoid sunny yellows. Paint it so that it looks like a green tree at sunset, not an autumn tree in full color.

Twilight
Just after sunset, earthy reds—especially Cadmium Red Deep—become dominant. Dull the intensity of your bright greens with reds. It's easy to establish a quiet mood by using these muted colors. Keep your scene free of sharply defined details that are apparent only in bright sunlight.

Evening Fog
Fog in morning light looks very different from fog in the evening. Yellowish grays are the dominant hues in the morning, whereas evening fog is dominated with red-grays and blue-grays. Because fog is dense humidity, bright colors are muted, details cannot be seen, and treetops usually disappear.

Painting Noontime

Noon light poses a few problems for the artist because the intense overhead light creates few shadows. This flattens everything out. Cast shadows are few and far between, thus eliminating many design opportunities. The intense light also bleaches out bright colors, which can lend to a lazy-day mood.

Fortunately, though, noon light does not change as quickly as does the light at sunrise or sunset, so it is a good time to paint on location. The challenge lies in painting a dramatic, energized scene in this type of light.

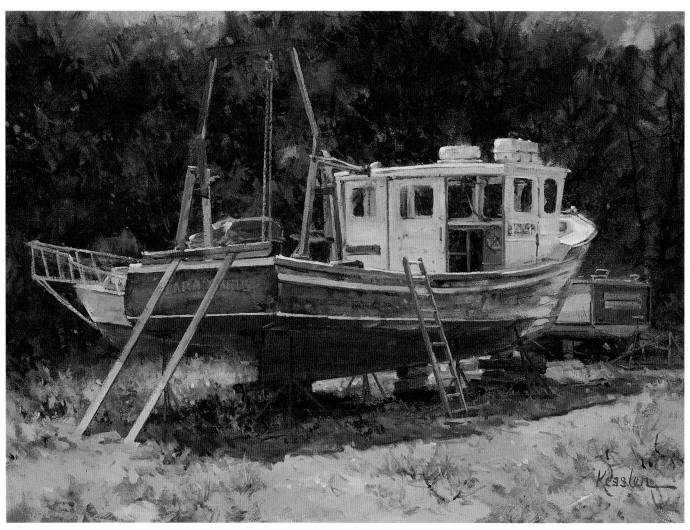

A Slightly Overcast Day at Noon
The mildly overcast light reveals the local colors of objects more clearly than intense sunlight would. I toned the canvas with Yellow Ochre to set the stage for this painting. Because the boats are at eye level, the highlights on them are minimal. The sun overhead creates an interesting cast shadow under the boat that acts as a secondary focal point. I kept this cast shadow fairly light in value and reddish to reflect the underside of the boat, indicating the sunlight that bounces off the sand and into the shadow. Due to the bleaching effects of the sun on sand, the foreground weeds are subtle in color and light in value. This helps to draw the viewer's attention to the focal point instead of to the bottom edge of the canvas.

CLARA MARIE • OIL ON LINEN • 18" x 24" (46CM x 61CM)

Painting Sunsets

The light of the descending sun creates many wonderful opportunities to use dramatic colors. Sunsets are generally warm paintings with extreme value differences. Backlighting is the key to capturing a sunset. The closer the sun is to the horizon, and the larger the object in front of it, the sharper the degree of contrast will be between the sky and the backlit objects in your scene.

Capturing a Sunset

A sunset can glorify just about anything—even this old abandoned barn. As in this sunset painting, your light source might be tucked just below the horizon or hidden behind objects such as clouds, trees or buildings. I started this canvas with a wash of Yellow Ochre and Cadmium Red Light and included a few cool hues such as Dioxazine Purple and Viridian Green. To draw attention to the center of interest, the setting sun, I contrasted complementary yellows and Dioxazine Purple in areas of the sky.

TWILIGHT • OIL ON LINEN • 18" x 24" (46CM x 61CM)

How the Atmosphere Affects Color

There are two major ways to create the illusion of depth in a painting. One is linear perspective: the use of vanishing points. The other is atmospheric perspective: the progressive cooling of a color as it recedes into the distance. I call this *color recession*.

Think of the atmosphere as a series of thin veils of airborne particles. The farther away you are from an object, the more veils there are between you and it. As you look through these veils into the distance, objects gradually become more indistinct as contrasting elements begin to weaken. Colors gradually become cooler and duller. The more dense the atmosphere is, the shorter the distance you can see before the colors mute into neutral grays.

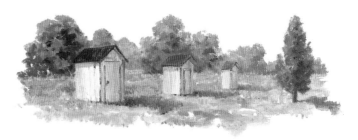

Colors cool as the day moves from morning to evening, and they also cool as you move from foreground to background.

Colors also become less intense as they recede. For example, green changes from a warm yellow-green in the foreground to cooler orange-greens and red-greens in the middle ground, and then to blue-greens and eventually cool grays in the background.

The Colors of Light, Adjusted for Depth

Just as the colors of light cool from yellow to red and on to blue as day progresses to night, so does the local color when you want to move from foreground to background. For example, green cools from yellow-green in the foreground to orange-green and red-green through the middle ground to blue-green and finally gray in the distance. For starters, modify your local color stepping through this chart to the degree of depth you want to portray. Also, progressively lighten the local color.

Gray

Ultramarine Blue

Quinacridone Red +
Ultramarine Blue

Quinacridone Red

Grumbacher Red

Cadmium Yellow
Medium + Grumbacher
Red

Cadmium Yellow
Deep

Cadmium Yellow
Medium

Lemon Yellow

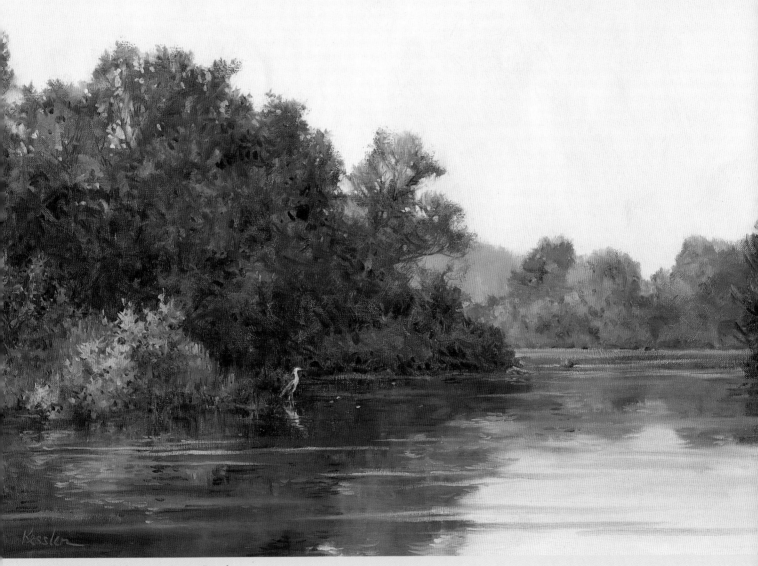

Combining Techniques to Create Depth

This painting conveys a sultry summer day on the river. The local greens in the large trees have been modified to reflect the time of day, the humid weather conditions and the onset of autumn. The trees in the distance are lighter, cooler and duller colors than the foreground trees. The local colors in the far distance are completely obscured by the blue-gray atmosphere. To add to this illusion of depth, overlap the trees, progressively reducing their sizes and simplifying details as you work toward the background.

LAZY RIVER • OIL ON LINEN • 18" x 24" (46CM x 61CM)

Create Depth Using Receding Colors

Strategically modify local colors in every area of your painting, from foreground to background, to convey depth. Gradually make your colors cooler and duller as they recede into the distance.

Add yellow to your foreground. Because yellow is warm and vibrant, adding it to your local colors will cause this area to advance. Add blue to your background. Because blue is a cool color, adding it will help shapes recede into the distance. Progressively modify your local colors in the middle ground with tints of oranges, reds and violets.

QUICK GUIDE TO PAINTING DEPTH

- Make colors more intense in the foreground and less intense in the background.

- Cool your colors as they recede into the distance.

- In the distance, make your value changes less distinct (light colors become darker, dark colors become lighter).

- Avoid similar values that create flatness. Diverse values create space.

- Make objects progressively smaller as they recede into the distance.

- Make objects less distinctive in the background by simplifying details and softening edges.

- Overlap objects to step into the distance.

- Use linear perspective (converging lines) to imply depth.

- Use division of planes (foreground, middle ground and background).

- Use thick paint in the foreground.

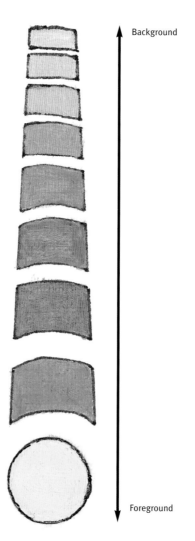

Background

Foreground

Color Recession of Yellow Ochre
To help establish depth in the beach and cliffs of the painting on the opposite page, cool the local color (Yellow Ochre) progressively with each of the colors from the chart on page 82 and tint with white as needed.

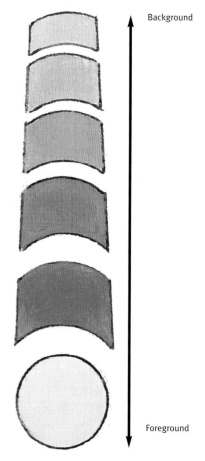

Background

Foreground

Color Recession of Blue
For the foreground water, start with tints of Phthalo Blue because it contains warm yellows and no cooling reds. Combine Phthalo Blue and Ultramarine Blue for the middle ground. In the distance, use tints of just Ultramarine Blue; this color contains a touch of cool red that makes it recede. For more depth add a cool red, such as Quinacridone, to mix a violet. Tint with white as needed.

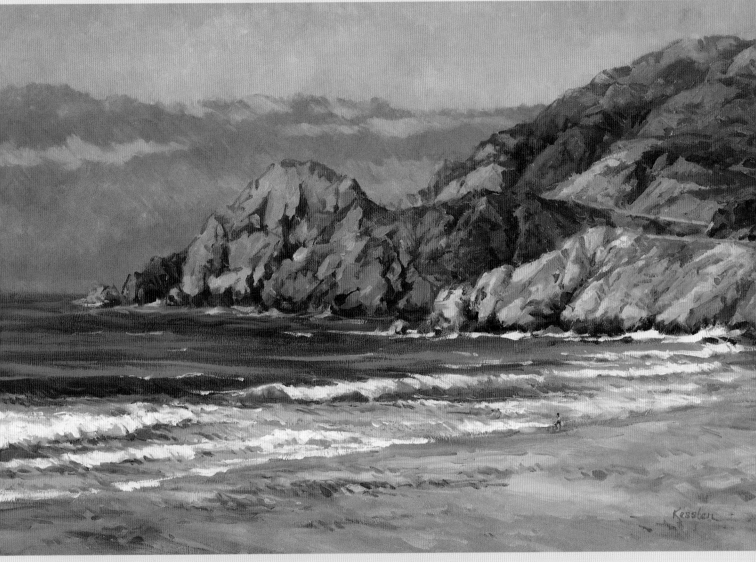

Creating Depth With Neutralized Color

The local color of the beach and cliffs in *Highway One* is an earthy Yellow Ochre. To create depth with receding colors, I applied warm ochre with tints of yellows in the foreground, then gradually cooled it with tints of oranges and reds in the middle ground. Finally, I modified the ochre with tints of violets and blues as I moved from cliff to cliff and out to sea.

I also used a wide range of values and contrasted the complementary colors Ultramarine Blue and Yellow Ochre to help establish depth in this scene. Remember, yellow (ochre) advances and blue (Ultramarine) recedes. Also keep in mind that value differences become nearly indistinguishable in the distance. Light colors become darker, and dark colors become lighter. For the small islands off the tip of the peninsula, I dashed in a neutralized blue and some light gray.

HIGHWAY ONE • OIL ON LINEN • 20" x 30" (51CM x 76CM)

Using Color Relationships to Develop Form

You can also create the illusion of form and volume by relating colors to each other. Contrasting light and dark, warm and cool, and bright and dull colors can result in believable forms.

Once you are familiar with how to change two-dimensional shapes into three-dimensional forms, such as circles into spheres, you can paint just about anything. Look around you; when broken down into basic structures, almost everything you see is a sphere, cylinder, cone or cube, or a combination of these forms. Even people are essentially just a collection of spheres and cylinders.

On rounded objects, colors gradually change from warm, light and bright...

...to cool, dark and dull.

Painting with one color and one value creates a flat, two-dimensional form.

By utilizing the elements of color, you can turn a circle into a sphere and a rectangle into a cylinder

Once you have developed basic forms by using accurate values, temperatures and color intensities, it is easy to reveal your subject. Like decorating a wedding cake, just add some details.

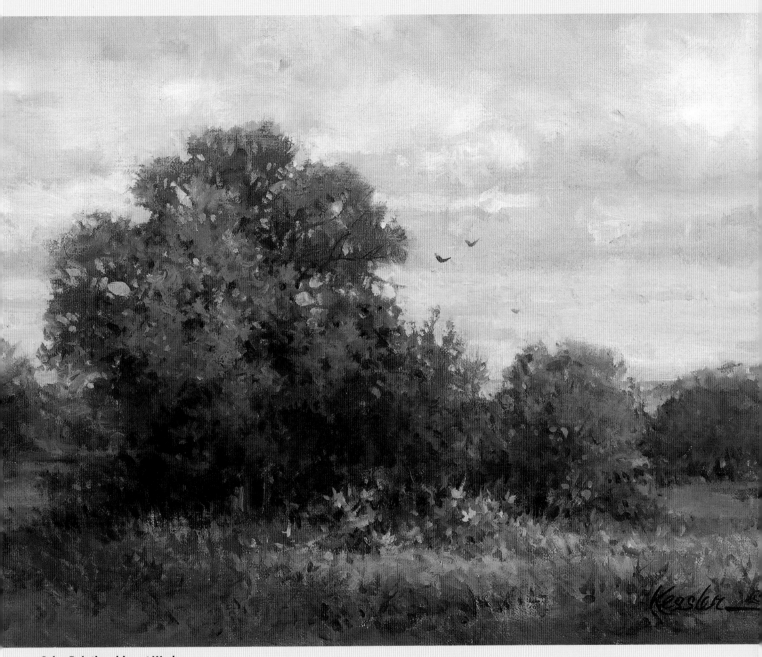

Color Relationships at Work

Prelude to Autumn provides an example of how to create voluminous forms with color contrast. The upper-right part of the dominant, spherical tree has the most warm light filtering through it, which is coming from the right. The lower left, in shadow, was painted dark and cool. The darkest, coolest accents at its base, where the cast shadow begins, are contrasted with warm, intense colors to the right of this cool area. The upper center of this tree advances due to the yellow and orange leaves indicated as last-minute details. Sky colors reflected onto the top of the tree help to round it out.

PRELUDE TO AUTUMN • OIL ON LINEN • 12" x 16" (30CM x 41CM)

Wrong

This effort to paint a white column ended in disappointment. Without utilizing the elements of color, it looks flat, like a simple rectangle.

Right

To create proper form, combine the elements of color and the principles of perspective. Make the surface of the plane closest to you the widest and diminish the width of these planes as you approach the outer edges of the cylinder. Remember: warm, intense colors advance and cool, dull colors recede.

Working Light Columns into a Painting

Shapes such as the support columns in this painting have a tendency to lead the viewer's eye up and out of the picture. However, by adding horizontals such as the overhanging branches you will stop the viewer's eye from exiting the painting. Also, you can de-emphasize the upper portion of the columns by avoiding strong contrasts and softening hard edges there.

Notice that under normal circumstances, colors from nearby objects are reflected onto the columns. The contrast of thick and thin paint also helps to convey volume, so lay the paint on thick in sunlit areas.

VIEW FROM THE TOP • OIL ON LINEN • 18" x 24" (46CM X 61CM)

Defining Dark Tree Trunks

The basic structure of these tree trunks can be established by modifying their local color—adjusting color values, temperatures and intensities as you move around the form.

Working Dark Trees into a Painting

Drama of Light shows the dark geometric shapes of the trees contrasted effectively against a light background. I painted the outer edges of the trees with loose brushstrokes to indicate the shaggy bark texture, and I reflected touches of the colors that you see in the snow onto the tree trunks. Now look at the cone-shaped, young pine tree on the far right in the foreground. You can create a sense of volume here too by simply modifying the principles used to create a cylinder.

DRAMA OF LIGHT • OIL ON LINEN • 18" x 24" (46CM X 61CM)

Consider the Weather

Weather conditions such as sun, fog and rain also affect how you see local colors, as do seasonal changes. Bright sunlight, cloudy days or fog challenge you to paint all types of atmospheric conditions. Select a color scheme to fit your scene, name your dominant color, and go for it. It's just a matter of using the right values, color temperatures and degrees of color intensity in the right place.

Sunny Days

For this intensely sunny day, I selected a complementary color scheme with blue as the dominant color and orange as the complement. The warm midmorning light comes from the upper left, so I washed my canvas with Yellow Ochre and Cadmium Yellow Medium. I used my complementary colors to mix a variety of hues: light and dark, warm and cool, bright and dull. Then I blocked in the boats quickly, since the light continually changes. I blocked in the distant rocks using more variations of those same colors, keeping lines loose and forms undeveloped. The viewer's imagination will fill in the missing information.

DINGHY DOCK • OIL ON LINEN • 18" x 24" (46CM x 61CM)

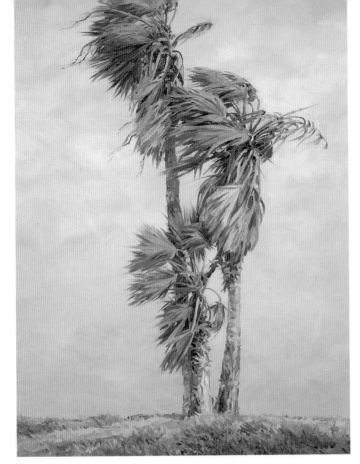

Morning Fog

A strong light source that is coming from one side normally reveals the form of objects with clearly defined, sharp details. Unmistakable shadows and highlights result, easily indicating volume. However, in this scene, the light is muted by a hazy atmosphere. To capture this foggy mood, first tone your canvas with Yellow Ochre. Keep the edges soft and the contrasts to a minimum except for the areas near your focal point—in this painting, the palm foliage on the tallest tree. For accents on the palm fronds, I used warm darks in the sunlight and cool darks in the shadows.

Coastal Breezes • Oil on linen • 24" x 18" (61cm x 46cm)

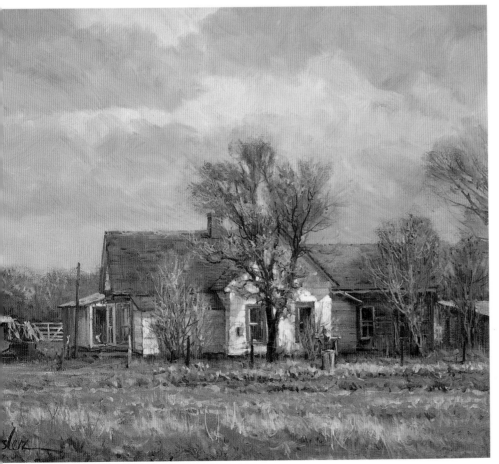

Cloudy Days

This painting reflects one of those cloudy-day situations. Following a brief afternoon shower, an opening in the clouds created a spotlight on the front of this house as well as the scarecrow, which became my center of interest. I selected an analogous color scheme on the Munsell wheel with a nice variety of beautiful neutrals. I used Yellow Ochre as my dominant color, with Ultramarine Blue as my complement.

I painted the sky with mixtures of Yellow Ochre, Ultramarine Blue and a few touches of Quinacridone Red. This was one time that I threw out the rule book: at the last minute, I added a foreign color, Cadmium Red Light, for the scarecrow's jacket. If you do introduce a new color, repeat it a few times throughout your painting.

Fall Gardening • Oil on linen • 20" x 24" (51cm x 61cm)

Atmospheric Depth on a Clear Day

Convey the bright light of a clear day early in the painting process. Rather than toning the entire canvas with a wash of Yellow Ochre, apply a wash of Yellow Ochre and Cadmium Yellow Medium on the lower part of your canvas. Then tone the upper portion of your canvas with Yellow Ochre and a touch of Quinacridone Red, as the sky is cooler than the foreground. You will find that this yellowish foreground will advance in the finished painting.

Color Recession of Green

To create the sensation of space, step your greens through the *Colors of Light* chart on page 82. In this example, a warm-green local color is progressively cooled. Lighten the values with white to adjust for depth. Compare this strip of colors with the sunny greens that recede into the distance in *The Haymaker*.

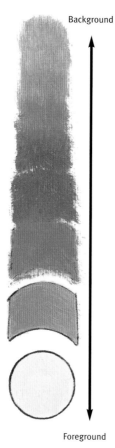

Background

Foreground

Creating the Illusion of Depth

To capture the crispness of the scene, modify your shadows with cool, neutral hues. For example, since the trees in the immediate foreground are in shadow, they will contain some cooler greens that have been neutralized with complementary reds and even violets. Start painting the sunlight by adding bright, slightly yellowish-green colors below the tractor. Modify your greens in the distance by gradually moving from warm to cool hues.

The blue sky was created with a combination of the yellows and blues used to mix the greens in the trees and grass (Cadmium Yellow Medium, Lemon Yellow and Phthalo Blue), with adjustments made according to the colors of the light. Now you can see why it is wise to mix your own greens: they will be perfectly compatible with the yellows and blues in the rest of your painting. Color harmony results instantly.

THE HAYMAKER • OIL ON LINEN • 24" x 36" (61CM x 91CM)

Capturing the Unique Effects of Side Light

Side light creates a unique situation. Because of the low angle of the light source, your light comes from one side of your painting instead of shining down from overhead. This creates both horizontal and vertical color changes. That is, if your light is coming from the left side, you must cool and darken your colors as you move across the canvas to the right side. Side light also affects your vertical colors as the light, warm and bright hues catch on the tallest objects in your painting. Using the chart below, darken, cool and mute your local colors one step at a time as you descend toward the shadowy foreground. Apply this principle when painting early morning and late evening scenes with tall objects such as mountains, skyscrapers or trees.

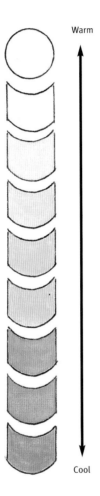

Color Recession for Snowy White
For side light on this scene, modify your local color (white) with tints of yellows at the snowy mountaintop. As you work down the mountain, gradually cool your colors until you reach the cool blues and grays located on the valley floor in the foreground.

Warm

Cool

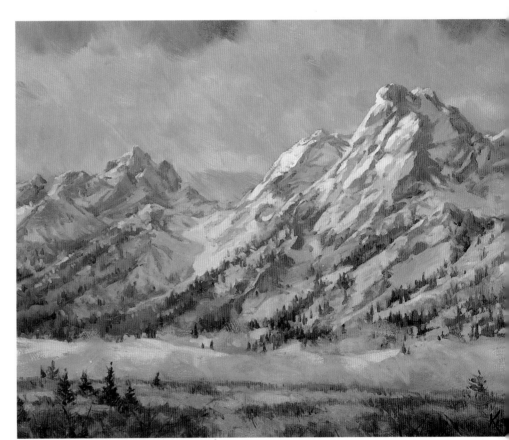

Snowy Side-Light Scene
To establish side light in the blue of this evening sky, I applied tints of warm Phthalo Blue on the left near the source of light, and cooled it with tints of Ultramarine Blue as I worked across the sky to the right. To enhance color harmony, I echoed the colors that I used in the foreground snow in the clouds, again starting with warm light colors on the left. I skipped the yellow hues and began with tints of muted orange-reds because I didn't want the clouds to compete with the yellowish mountaintop for attention. I used tints of grayed reds and blues for the clouds on the right—subtly receding from warm to cool and light to dark as I moved away from the light source. In the foreground, the values are kept dark, gradating to lighter tones in the distance, high on the canvas where the light hits.

P.S. A River Runs Through It • Oil on linen • 18" x 24" (46cm x 61cm)

Building Harmony in Morning Light

MATERIALS

SURFACE
16" x 20" (41cm x 51cm) cotton canvas

BRUSHES
Nos. 2, 3, 5 and 8 filbert bristle

No. 1 round bristle

OILS
Cadmium Red Deep

Cadmium Yellow Deep

Cadmium Yellow Medium

Dioxazine Purple

Grumbacher Red (or Winsor & Newton's Cadmium Red)

Lemon Yellow

Phthalo Blue

Quinacridone Red (by Grumbacher, or Winsor & Newton's Permanent Rose)

Titanium-Zinc White

Ultramarine Blue

Viridian Green

Yellow Ochre

OTHER
Facial tissues

Gum turpentine and jar

Palette knife (for mixing and applying paint)

Pencil and paper

Ruler

● For the following demonstration, I wanted to show an autumn day, dawning and full of promise.

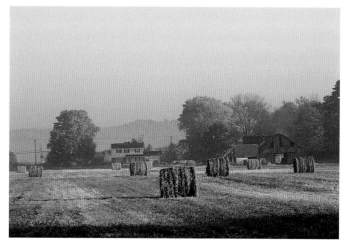

Reference Photo
I was attracted to the white house, the barns and the hay bales in strong sunlight. The heat of day was burning off the morning fog. Because I wanted to express the time of day rather than feature the buildings, I simplified the composition by eliminating the house. Don't fall into the trap of squeezing too many items into a limited amount of space.

MIX IT UP

The materials list includes a warm and a cool hue for each of the three primary colors. Try mixing your own secondaries from these colors. A quick refresher:

- Orange: Cadmium Yellow Medium + Grumbacher Red

- Violet: Ultramarine Blue + Quinacridone Red

- Warm green: Cadmium Yellow Medium + Phthalo Blue

- Cool green: Lemon Yellow + Phthalo Blue

If you don't want to mix your violets, you can substitute Cobalt Violet and Dioxazine Purple as your warm and cool versions respectively. Likewise, you can substitute Permanent Green Light and Viridian Green for your warm and cool greens. Also, you can add Yellow Ochre and Cadmium Red Deep to your palette instead of mixing these semineutrals from scratch.

As you mix, remember that when comparing two hues of one color, the one with the most yellow in it is the warmest. (Phthalo Blue is warmer than Ultramarine Blue, for example.) Warm up cool tube white with a touch of Lemon Yellow.

Select Your Color Scheme
You could use the complements orange and blue on the triadic color wheel for this painting, but that would be very limiting. Instead, use the analogous color scheme on Munsell's wheel, shown here. With several hues of orange for your dominant colors, Phthalo Blue is your complement; Dioxazine Purple and Viridian Green are your discords. Look toward the center of the wheel from your oranges to see all the delightful neutrals you can mix.

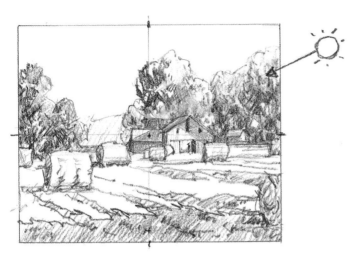

Value Plan

Divide a rectangular format into three horizontal sections, making unequal bands for the sky, the barns and trees, and the field. Avoid placing objects in the exact center of your composition. Plan your values, making the sky the lightest value and the barns and trees the darkest values. Establish the doorway of the main barn as your focal point. Arrange cast shadows so they are moving away from your light source, moving the viewer's eye from left to right. The two partial bales on the right edge of the canvas act as eye-stoppers, leading your viewer back into the painting.

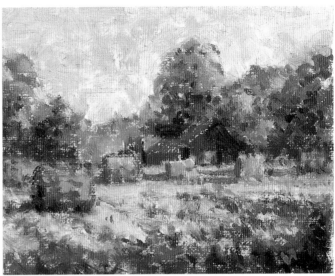

Color Study

Make a small color study [(this one is 3" x 4" (8cm x 10cm)] to finalize the colors that you will use in your painting. This is a chance to try out various color choices and develop your ideas further. Experiment with your options and select the best one for your painting.

Use a variety of oranges mixed from Cadmium Yellow Medium and Grumbacher Red. Modify them with Cadmium Yellow Deep, Yellow Ochre and a touch of white. Then, mix your own greens with Cadmium Yellow Medium and a touch of Phthalo Blue for warm yellow-greens, and Lemon Yellow mixed with Phthalo Blue for the cool blue-greens. Mute these greens with your various orange mixtures.

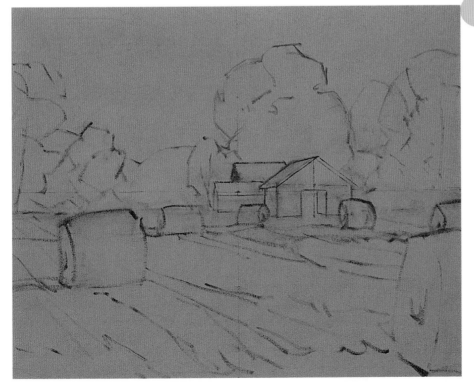

1 TONE AND DRAW

With a paper towel dipped in turpentine, mix together Yellow Ochre and Lemon Yellow directly on your canvas. Divide the canvas into thirds. Load a no. 1 round bristle with Yellow Ochre and rough in the landscape. Wipe out any unwanted lines with a dry facial tissue. Practice repetition with variety by varying the height and shape of the trees and bales of hay. Design with different numbers: three barns, six bales.

2 START BLOCKING IN YOUR COLORS

With your no. 5 filbert bristle brush, block in the buildings and shadows using variations of Ultramarine Blue and Dioxazine Purple. If an area gets too dark, simply lighten it by blotting with a facial tissue. Continue blocking in your color values. On your palette, mix warm darks with various combinations of Yellow Ochre, Cadmium Red Deep and some warm yellow-greens. Clean your no. 5 brush and use these reddish browns on the sunny areas of the barn. Repeat this color in the sunny dark areas of your trees. Clean your brush and place orange complements for contrast near your center of interest using mixtures of Cadmium Yellow Medium and Grumbacher Red. Keep your brushwork loose.

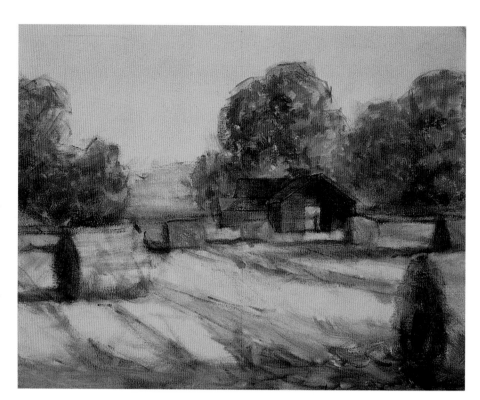

3 FINISH YOUR VALUE PLAN

Before starting the sky, finish laying in your value plan. With the side of your no. 2 filbert, suggest tree trunks and branches. Smudge to lose edges here and there. Paint the smaller branches lighter in value than the larger ones. Working outward from your center of interest, continue painting the field. Repeat the same color mixtures that you used in step 2 for the barns and trees, but emphasize yellows rather than oranges and reds. (Remember, yellow advances as it is the first color to catch the eye.)

At this point, your thin underpainting should be dry in about fifteen minutes.

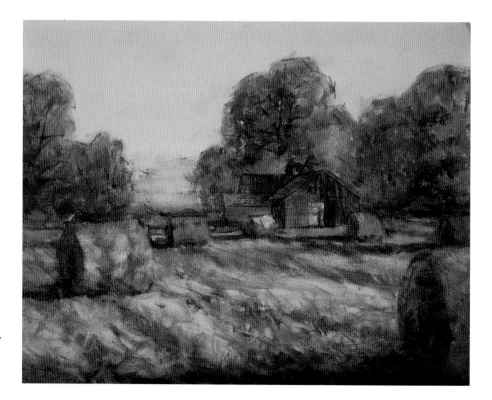

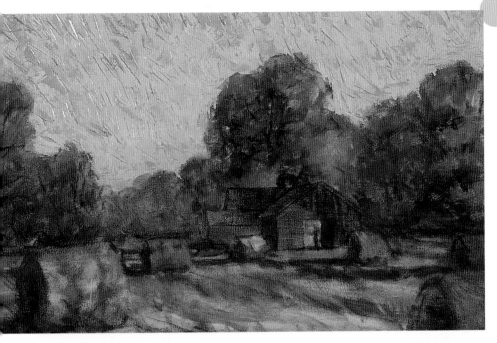

4 Begin the Sky With a Palette Knife

Mix tints of the red, yellow and blue separately on your palette. With your palette knife, overlay your underpainting with dots and dashes of these tints. Because of the morning light here, the right side of your canvas will be predominantly yellows (tints of Lemon Yellow and Cadmium Yellow Medium). Use your cooler tints of mixed oranges, reds (Quinacridone Red) and violets (Dioxazine Purple) as you move away from the sun to the left.

Now add your cool colors. Nearest the sun, add a tint of warm Phthalo Blue; farthest away, add a tint of cool Ultramarine Blue. Also apply tints of Ultramarine Blue and Cadmium Red Deep near the horizon to indicate distance. When painting a clear-day sky like this one, it is important to keep the values of your sky colors similar.

5 Finish the Sky

Step back a little from your painting, then start blending this thick paint with a dry no. 8 filbert bristle brush. Crosshatch at random, but leave the colors somewhat broken as overworking will dull your sky to a gray hue. Start with the warmest color, yellow, working into the oranges and reds. Without cleaning your brush, continue into the warm Phthalo Blue, and lastly, into the cool Ultramarine Blue.

If you need to rework some areas, lift off or add more paint with your palette knife. Then, with a clean, dry brush, start blending in the new color splotches, starting with the warms and working into the cools. Caution: don't make any modifications like this after the paint has begun to set. Sticky paint doesn't blend.

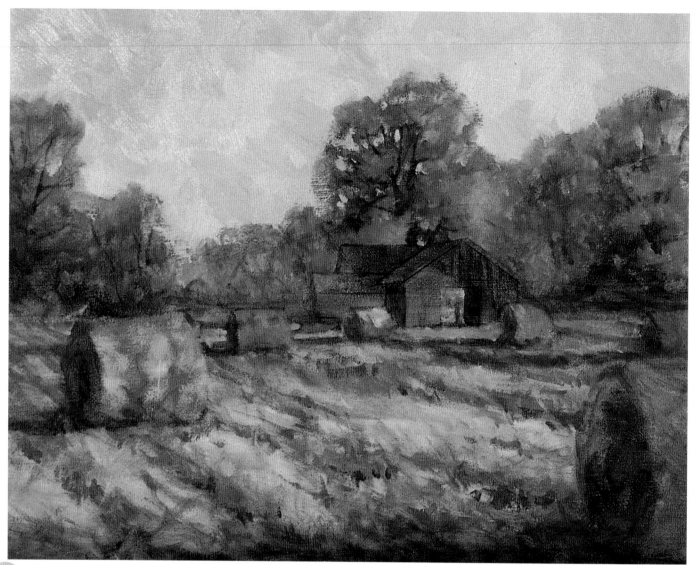

6 ADD SKY HOLES AND DEVELOP THE DISTANT TREES

Use some paint left over from the sky—a neutralized mixture of reds, yellows and blues—to paint the sky holes in the major trees. Modify the color as needed. (The smaller the hole, the darker, duller and cooler the color should be.) Make these negative spaces interesting by varying their size, shape and placement. Save some of this left-over sky color for later, to reflect light on the field, the tops of trees and the hay bales. (I call this "skyshine.")

Start developing the distant trees with tints of Cadmium Red Deep, Ultramarine Blue and cool greens.

PAINTING POINTERS

As you head into the final stage of the painting, remember to:

- Build up thick paint in the sunlit areas and keep darks thin.

- Use creative brush marks: slashes, dashes, dots, verticals, horizontals and diagonals.

- Save defined edges for your center of interest and leave others lost.

- Use warm darks in the sunlight and cool darks in the shadows.

- Make cast shadows dark and sharply defined at their source, then gradually lighter, softer and cooler (reflecting sky colors) toward the distant end.

- Reflect touches of your sky color on the ground, adjusting the values as needed.

- Modify areas of your painting that you are dissatisfied with using touches of color that stay within your color scheme.

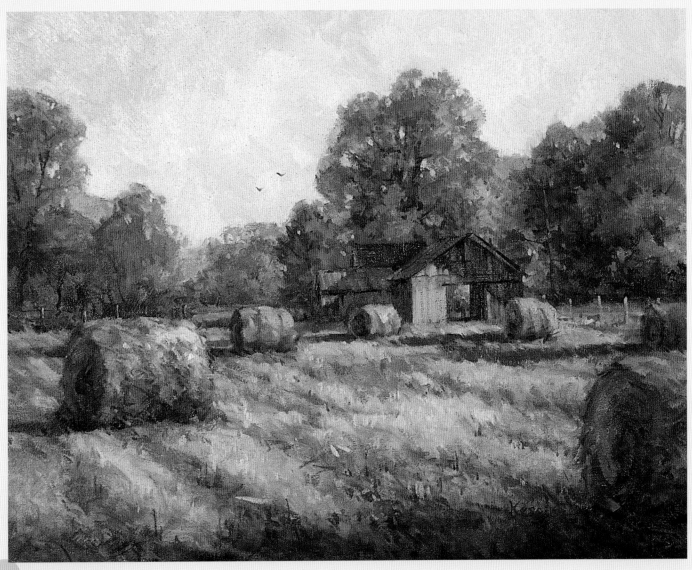

7 FINISH DETAILS

Paint your colors thickly in this step, using mostly no. 4 to no. 6 filberts. Refine your center of interest and work out from it, repeating all the colors you have used so far. Suggest individual planks and imperfections in the barns for character. Warm and lighten the the main barn's outlines. With your no. 1 round bristle, add fence posts to knit your buildings into the scene. With your signature brush, add some birds to the sky. With your no. 2 filbert, add darks to the tree foliage using tints of Cadmium Red Deep, Ultramarine Blue and Viridian Green. Add a few more skyholes and limbs. Don't let the minor trees upstage the main tree just above the barns.

Repeat complementary barn colors (Phthalo and Ultramarine blues) in the cast shadows. With your no. 1 round bristle, add Grumbacher Red to transition from sunlight to shadow here. Soften the edges of the trees, hay bales and cast shadows as they recede into the distance. Add skyshine highlights, then switch to your orange mixture and Yellow Ochre to paint highlights around the barns. For excitement, dash a few of your discords, Viridian Green and a red-violet (Ultramarine Blue and Quinacridone Red), near the center of interest. Sprinkle Lemon Yellow, Cadmium Yellow Medium and Cadmium Yellow Deep onto the sunny foreground. Suggest some stubble in the field, but let the viewer's imagination fill in the rest.

BARNS AND BALES • OIL ON LINEN • 16" x 20" (41CM x 51CM)

MOUNTAIN AIR • OIL ON LINEN • 18" x 24" (46CM x 61CM)

6

DESIGNING WITH COLOR

In this chapter we will look at some aspects of design and how they relate to color. If you think about it, constructing a painting is similar to building a house from the ground up. You would not start building your dream home without first doing some planning in advance. Will it be large or small, colonial or contemporary, sunny or cozy? Just as you would visualize and build your dream home, so too can you visualize and build your painting. This chapter will provide you with a painting process that works—from the visualization and composition, to the value plan, harmonious color scheme and final details.

Visualize Your Painting Idea

Visualize your finished painting as you would visualize your dream home. See your painting as large or small, horizontal or vertical, and predominantly light or dark, warm or cool, bright or dull. What mood would you like it to convey? What is it that you want the viewer to remember about your subject? Close your eyes and let your mind wander.

If you are using reference photos for inspiration, do some creative editing in your mind. What would you keep, emphasize or remove for the finished painting?

● ● ● ●
MAKE A WISH LIST

In painting this autumn scene, I envision:

- **MOOD:** romantically awe-inspiring

- **VALUE DOMINANCE:** light

- **TEMPERATURE DOMINANCE:** warm

- **INTENSITY:** bright, but not too bright

- **VALUE RANGE:** limited (no extreme lights or darks)

- **LOCATION OF LIGHT SOURCE:** over the viewer's right shoulder

- **COLOR SCHEME:** complementary (predominantly orange with blue)

- **CENTER OF INTEREST:** the middle ground

Picture Your Dream Painting

If you are inspired by a photograph, evaluate its good and bad qualities. In this landscape, observe that the early morning fog is lifting. The too-light immediate foreground and the farmhouse at the outer edge detract from the seasonal beauty of the scene. Though the telephone poles are well placed—an artistically uneven number, at unequal distances apart—they are still unattractive telephone poles.

I want to evoke a romantic, awe-inspiring mood based on this scene. A predominantly light, warm and not-too-bright painting would be more romantic than a predominantly dark, cool and dull one. Autumn is a time for contrasts, so a complementary color scheme of orange and blue (predominantly orange) is appropriate. Emphasizing the middle ground with a contrast of values will lead the viewer's eye to the center of interest—down the road and into the mystical distance.

Create a Blueprint

You would not build a house without a floorplan or a blueprint. Similarly, you need an organized compositional plan before you begin painting—a small sketch, as a minimum. Decide which design possibilities will work best for your subject.

After selecting the canvas size and shape that best suit the concept for the scene or subject, decide how to divide this shape to enhance your theme. Consider both formal (symmetrical) and informal (asymmetrical) plans, as well as such traditional letter-inspired compositions as L, O, S, U or Z. Concentrate on developing rhythmic movement toward your center of interest, making sure to balance shapes and establish depth.

There are basic rules of logic for laying out the floorplan of a house. For instance, you would not place the dining room off the bedroom; you'd put it near the kitchen. There are similar rules for composing your painting. For instance, you would not tuck away the center of interest in a corner or along the edge of the painting. Placing it in a more central location, as long as it's not dead-center, makes the painting more interesting.

If you take time to lay out your idea in a simple black-and-white sketch, you can prevent problems of all kinds. These compositional sketches are especially essential in landscape painting since you cannot move the actual objects or the light source as you can in still life or portraiture.

concrete driveway

160.00'

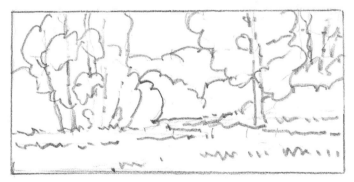

Draw the Plans for Your Painting
Since nature is inherently informal, the autumn landscape I want to paint lends itself to an asymmetrical design. This plan leads you into the distance through a U-shaped composition formed by the trees on each side of the road. After making several more sketches, I decided a conservative, horizontal rectangle was my favorite format for this scene.

Lay the Foundation

Once you've planned your composition, it is now time to lay the foundation: the value plan. Just as the foundation for a house must be firm and structurally sound, so too should the foundation for your painting. Like the rooms in your home, the light shapes in your painting must be linked together by "narrow hallways" and "winding staircases." You can even include a few clever "closets" or spaces where the viewer can pause to investigate.

Contrast lights and darks to create balance, and link these shapes together for rhythm and movement. Place your lightest and darkest values at the center of interest.

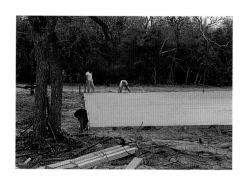

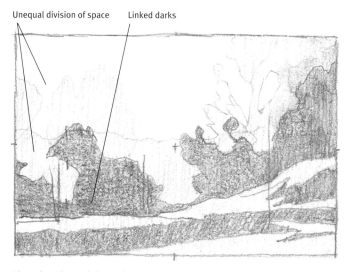

Unequal division of space Linked darks

Plan the Flow of the Painting
Simplify your painting idea into a few major shapes of value that form the overall design. In this painting, the negative shape of the sky flanked by two tree shapes on either side (forming a U) is interesting, and the canvas can be appropriately divided into one-third sky and two-thirds land. (Remember, no half and half!) Make the other shapes varied and interesting, keeping in mind repetition with variety. Link together the dark patterns running through the fairly light painting to create an organized sense of flow.

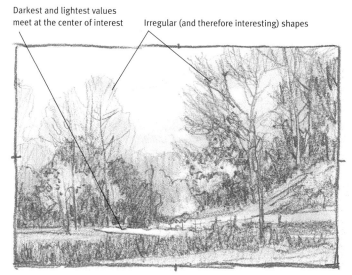

Darkest and lightest values meet at the center of interest Irregular (and therefore interesting) shapes

Plan the Values and Double-Check Your Design
Work out a more detailed sketch using a limited range of values. Five values are used here: light, halftone light, middle, halftone dark and dark. Make sure that the dimensions of the sketch will scale up correctly to fit the canvas dimensions you've chosen.

Check your value sketch for good design elements. Did you divide the canvas so it is predominantly a landscape or a skyscape? Did you make the sky itself an interesting, irregular shape instead of a boring, perfectly rectangular or square shape? Have you placed your darkest and lightest values at the center of interest?

Construct the Framework

Once your values are planned, you are ready to construct the framework—the color plan—upon which you'll hang the final decorations and details of your painting. Recalling the mood you wish to convey, construct a harmonious color scheme that will support the painting. Select an overall color that will enhance your theme, and tone your canvas with it to set the mood from the beginning.

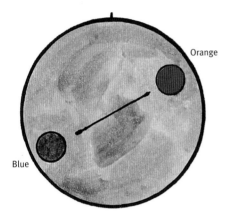

Orange

Blue

Complementary Color Scheme

Tone Your Canvas and Make a Drawing
I toned my painting surface with a grayed orange wash (orange mixed with a tiny touch of Phthalo Blue) to establish the warm lighting conditions of the day and to create a fairly light value, setting the key for the predominantly halftone/light-halftone value plan. I then made a simple line drawing of the landscape with a warm dark (a reddish brown). Since it is easier to cool a warm than to warm a cool, these drawing lines will easily be absorbed into the finished painting without inadvertently cooling the edges of the objects painted on top of them.

Raise the Walls

Establish unity and harmony with beautiful, expressive colors that follow the traditional color scheme you've chosen. Continually use your value drawings to guide you as you finish transferring your plan to the canvas. Use a large brush to keep it simple. Don't get hung up on the details yet; you wouldn't hang wallpaper and drapes before your house had walls.

Block in your color scheme thinly at first. Once this underpainting has dried, step back and check it to be sure it is what you had in mind. If you are satisfied with it, begin laying on the thick paint, starting with big brushes and working down to smaller ones. If you are not satisfied, make corrections now, as it is difficult to do so later when the paint is thick.

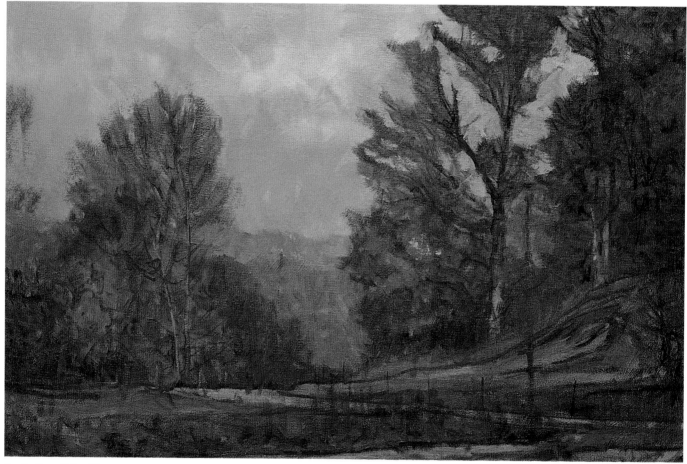

Begin Your Color Plan
Emphasizing opposites on the color wheel (here, orange and blue) provides contrast at the focal point, where the road curves in the middle ground. Suggest neutralized tree shadows with various warm mixtures of Yellow Ochre, Cadmium Red Deep and a touch of Phthalo Blue (reddish browns). Plan to reflect some cool colors into these shadows later.

Paint the blue of the upper sky starting with tints of Lemon Yellow and Phthalo Blue. As you work your way down the canvas in the sky area, introduce Ultramarine Blue and oranges and add Quinacridone Red tints near the horizon. Apply thick paint using active brushwork in the sky (the source of light), as light that reflects off the paint texture will enhance the sense of light in the painting.

Add the Decorations

Now you can decorate your structurally sound painting to your heart's content. Some artists elect to skip the details altogether, leaving the painting impressionistic. Others decide to develop it all the way to photorealism. There is no right or wrong place to stop painting. Whenever you feel comfortable with your picture, quit.

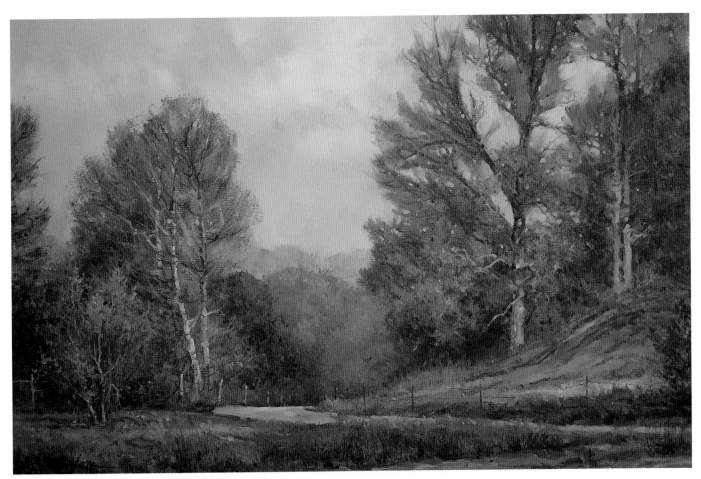

Add Final Details

Trees are suggested in the distant haze with tints of Ultramarine Blue and Cadmium Red Deep. The sunny parts of the middle-ground trees are established with Yellow Ochre, mixed orange and Quinacridone Red (Permanent Rose can be substituted for Quinacridone Red). I cooled the shaded tree just above the curve in the road with a warm mixed green and Cadmium Red Deep.

Add a few bright jewels with thick paint in the foreground trees, using Cadmium Red Light, Cadmium Yellow Medium and Cadmium Red Deep straight from the tube. Add your lightest highlights and darkest accents, being careful not to add distracting details in the foreground. No harsh-looking telephone poles in this picture! As for the road, tree trunks, foreground grass and other details, keep most of your paint edges soft to enhance the romantic mood of the painting. Any well-defined edges should appear near the center of interest—the curve in the road—to draw the viewer's attention there.

AUTUMN DAWN • OIL ON LINEN • 20" x 30" (51CM x 76CM)

Recognizing Weak Design

It's easy to recognize a poor design because chaos prevails. Just like stepping into a cluttered house, you won't feel a sense of planned order—you'll just notice a lived-in look. You'll find haphazard lights and darks, warms and cools, and brights and dulls scattered about like toys, books and clothes.

A good design has a sense of visual order. It brings many different elements together and is able to organize them into a unified whole.

Consider *Seaside Excitement*, a painting that has potential, but doesn't quite measure up because it has some design problems. Beautiful colors and fancy brushwork will not save a poor design.

All trees are on the far side of the island. Lower the base of the far-left tree and eliminate the two trees on the right for more interest.

These three trees are too similar. Lighten and cool the center tree to move it back in space.

Value changes in the sky are too similar. For contrast, use broken colors and loose brushwork to darken the blue of the sky. Add a few highlights to the clouds.

Same-width shapes are boring. Redesign using repetition with variety.

Perspective problems make the distant water look as if it is below a dam. Redesign or replace the distant water and beach with foreground rock formations.

Three focal points compete for attention. Select one and use contrasting elements to emphasize it while de-emphasizing the others. Avoid contrast at dead-center.

A Closer Look at a Problematic Design

The basic composition—an off-center pyramid on a squarish canvas—forms a solid design structure, but it is not executed well. The design in the water—lights and darks linked together in the lower-left corner—gracefully leads your eye into the painting. The crashing wave on the right guides you up the side of the island, and your eye naturally slides back down the left side. It continues moving from left to right along the front edge of the island, but then the lack of a strong focal point leaves you wandering aimlessly.

A harmonious color scheme is not evident, and the painting lacks a dominant temperature (it looks half warm, half cool). A stronger complementary color scheme of Ultramarine Blue and Yellow Ochre, with one color obviously dominant, would be more interesting. Make the cool color dominate by reflecting the cool water and sky colors onto the island rocks.

SEASIDE EXCITEMENT • OIL ON LINEN • 20" x 24" (51CM x 61CM)

Good Compositions Create Movement

To compose a good design, you must organize objects and people in simplified arrangements. To move the viewer along a visual path through your painting, create contrast with values and colors and use design techniques such as linear perspective and overlapping.

There are many ways you can suggest movement in your paintings. Arranging the elements of a scene into a letter-shaped composition (L, O, U, S or Z) is one of the easiest ways to create a path for the eye from the start. Let a gentle S-curve river or road lead to your focal point, or use an O or a U composition to tunnel your way through a forest.

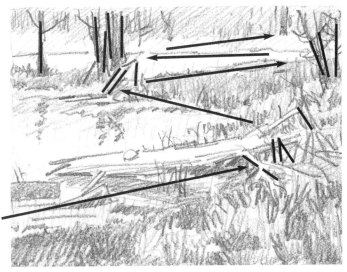

Design With a Z
A Z-shape composition leads the viewer's eye from the lower-left corner of the painting to the upper right in a zigzag movement. To stop the viewer's eye from wandering off the canvas, I added strategically placed verticals (trees, tall grass), or eye-stoppers. Repeat the zigzag movement throughout your painting to keep your composition interesting.

Finished Painting
You can contrast light and dark to create subtle linear movement in your painting. To enhance perspective, diagonal lines in the foreground give way to horizontal lines in the distance. Animals and people attract attention, so don't place them in the center or near the edges of your canvas.

TURTLE LOG • OIL ON LINEN • 18" x 24" (46CM x 61CM)

Balancing Your Composition

Symmetrical design, although formal and static, practically guarantees that there will be balance, as one side of the painting is a mirror image of the other. The elements of design automatically work together to create a sense of visual order.

However, most of your compositional designs will be asymmetrical. In these informal compositions, disparate objects are emphasized in such a way that they visually balance each other. By simply adjusting the value, temperature and intensity of their colors, you can adjust the balance. For example, a large shape painted in dark, cool, muted colors can be balanced by a small shape that is warm and bright. Remember that in a well-balanced design you can't remove an object or make major changes without disturbing the balance of the whole.

A Symmetrical Design
Symmetrical designs work well for man-made subjects like this street scene, because symmetry is man's idea of beauty. Nature is usually asymmetrical. To create a spark of interest in this situation, emphasize contrast near your focal point (the clock tower).

COURTHOUSE SQUARE • OIL ON LINEN • 20" x 24" (51CM x 61CM)

Balancing an Asymmetrical Design

To create this informal design, I linked the shapes of the mother and daughter with cast shadows and placed them to the right of center. The weight of this linked shape is counterbalanced by the distant island on the left. I painted the mother with neutral colors and counterbalanced her with the smaller, more brightly colored child. The temperature and intensity of the smaller shape gives it more weight.

To prevent disorder, link darks (or lights) together into one attractive, balanced shape. For example, notice how the mother's hair overlaps the rocks, connecting these dark shapes. The blended colors in the mother's dark hair and clothing are continued in the broken colors of the dark rocks.

ATTAGIRL • OIL ON LINEN • 18" x 24" (46CM x 61CM)

Planning Ahead

Planning your compositions can reduce the number of problems you face while painting. Basic design mistakes, such as balance problems created in the early stages of the painting process, can't always be solved later. It's well worth it, then, to do some preliminary planning.

Choose a Color Scheme
Dominance of one color is a key to unity, so select that dominant color wisely, balancing it with its complement and optional discords. I chose the sunny yellow ochres of the rocks as my dominant color. Munsell's color wheel reveals a blue-violet (Ultramarine) as the complement, a great color for the flowers.

Working With Reference Materials
If you're working from photos rather than on location, there is no hurry, as the light is not going to change. Study your source material and select a canvas shape and size that supports the mood you wish to convey. Consider the general implications of each format: vertical suggests power, horizontal is more relaxing, and square suggests stability.

Develop a Composition
Draw several small sketches, exploring different compositional possibilities. Look for opportunities to contrast values, colors, lines, sizes and shapes, emphasizing contrasting elements near your center of interest. Create patterns and directional movement. This boxy shape stabilizes the explosive nature of springtime.

Ensure Contrast
Simplify your full-value sketch into its most basic statement, a two-value study. This will help you prevent half-and-half problems: half light/half dark, half vegetation/half rocks, and so on. Group light (or dark) objects and link them together so your pattern rhythmically flows across your canvas.

● ● ● ●
LIST YOUR PAINTING GOALS

With so many decisions to make, you may want to write your goals down so you don't get off track during the painting process.

1. Identify the emotional theme: joyful, romantic, somber, etc.

2. Locate your light: its source and intensity.

3. Pick your format: canvas shape and size.

4. Select a value theme: predominantly light or dark.

5. Plan the color temperature: predominantly warm or cold.

6. Plan the color intensity: predominantly bright or dull.

7. Choose a dominant color.

8. Select a color scheme: complementary, analogous, etc.

9. Sketch the composition: a small three-value sketch (black, white, gray) done to scale. Check the balance and aesthetic appeal of the design.

10. Divide the space: predominantly landscape or skyscape, or a closeup of an object.

11. Emphasize one plane: foreground, middle or background.

12. Locate the main focal point: off center, but not near the edges or corners.

13. Plan a path: the direction for eye movement through the painting to the focal point.

14. Dramatize important areas; de-emphasize or eliminate distractions.

A Well-Executed Design

Annual Celebration is bright and explosive—a reward for planning ahead. Starting at the lower left, the spiraling movement in the composition leads you through the painting. The yellows in the outer ring of the spiral guide you to the complementary bluebonnets which burst open in the area to the right of center.

Repetition with variety helps to pull this painting together. The rock colors repeat in the foreground sand; sunny flowers are juxtaposed with shaded ones; and the fracture lines in the rocks are repeated elsewhere in the lines of the sticks, roots and blades of grass. These lines direct the viewer to the heart of the painting.

ANNUAL CELEBRATION • OIL ON LINEN • 20" x 24" (51CM x 61CM)

How Far Should I Take the Details?

Details are the final brushstrokes in your painting. Like window curtains, they decorate. You can spend half an hour or days painting them. Remember, however, that extensive and beautiful details can't rescue a bad design. Conversely, poorly painted details can ruin a great design.

You must decide how far to take the details in your paintings. You could:

- Leave your painting just as it looks after you've blocked in values and colors, only overlaying your underpainting with thicker paint.

- Develop it to an impressionistic stage by refining the basic light and dark shapes and color masses using broken (or unblended) color.

- Develop it to an impressionistic stage and then add details to one of the planes—foreground, middle ground, or background.

- Develop it to an impressionistic stage and then add details at the center of interest only.

- Continue developing other areas of details to create secondary focal points without allowing these areas to compete for attention with your primary center of interest.

- Refine your painting until it is photo-realistic—fully developed with details.

There is no right or wrong place to stop painting: it's a personal decision. You may want to experiment with a number of these styles. The point is, if you construct your painting one step at a time, doing your best with each step as you go, the amount of detail you place on your attractive, stable design should not make or break the painting.

> ● ● ● ●
> ## USE CONSISTENT BRUSHWORK
>
> Brushwork and the texture created with thick or thin paint are an important part of painting details. Keep your brushwork consistent. I choose to avoid having both palette knife marks and brushwork in the same painting, since mixing these techniques might draw the viewer's eye away from my theme.

Be Brave With Your Paint

Most beginners don't use enough paint, typically for two reasons: (1) oils can be expensive, and (2) they lack experience in boldly handling thick paint. Work toward creating a juicy, luxurious look—and don't be timid. Using assertive brushstrokes, experiment with thick paint. Begin each painting with your darks, leaving them relatively thin, and use thicker paint to build up to the lights. Pile on the paint in the light areas near your center of interest (here, the sunny autumn trees) and wherever you want to create a sense of glare (sun reflecting off water or snow, for example).

Notice the snow patterns on the mountaintop in this painting. The thick, light color of the snow was scumbled (or dragged) over the thinly painted dark mountain. The contrast of thick and thin creates reflected light in these selected areas, greatly enhancing the scene.

MOUNTAIN PRIDE • OIL ON LINEN • 18" x 24" (46CM x 61CM)

Designing With Limited Details

The detail work in *Timberline Ridge* is very limited. Paintings like this succeed or fail depending on the success of your basic design. You have to tell your story through the elements of the design (value, line, color, pattern, movement, shape and size) rather than through the details.

TIMBERLINE RIDGE • OIL ON LINEN • 18" x 24" (46CM x 61CM)

Getting the Details Right

Don't just paint the details without considering everything you've learned up to this point; otherwise, the details will seem to float on top of the scene instead of truly being a part of it. Remember that these same rules apply to details:

- Dark values become lighter as you move into the distance, and light values in the foreground become darker.

- Colors appear warm in the foreground and cool in the distance.

- Warm darks exist in the sunlight and cool darks exist in the shade.

- Bright colors advance into the foreground and dulls recede into the distance.

Continue using your chosen color scheme as you add the details. Don't introduce new colors during this final phase of the painting or they will disrupt your color harmony. Contrasting complementary colors can create vibrating details, but avoid this in the corners or along the outer edges of your painting, or they will draw attention away from the center of interest.

Working With Details

When it's time for details, you must take control of those contrasting elements. If the darks in the middle-ground trees on the right had been repeated in the distant trees on the left, the feeling of depth would have been lost. The sunshine on the foreground is yellow, but the sun on the distant tree (at left) is cooled to a pinkish violet, an example of using color recession to establish depth. I made the calf on the right the star of this show by emphasizing the contrast of lights and darks, warms and cools, brights and dulls, complementary reds and greens (the calf and the grass), and by depicting the calf in motion. The two other calves are standing still among subdued contrasting elements.

SPRINGCREEK • OIL ON LINEN • 20" x 30" (51CM x 76CM)

Practice Drawing Your Subject

If you are going to paint the details in your work, don't try to fake it with a dash here and a dot there. Become very familiar with the subject matter you plan to use in your paintings. Carry a sketchpad and practice drawing complicated or unfamiliar subjects before you get out your paints.

Heightening Details at the Center of Interest

This painting concentrates on the detailed brushwork at the center of interest, the child testing the water temperature. Contrasting elements in the rest of the painting are subdued, with no extreme lights or darks, no sharp edges, no juxtaposed complementary colors, and so on.

TESTING THE WATER • OIL ON LINEN • 18" x 24" (46CM x 61CM)

Quick Study in Oils

Inexperienced in painting people, I first practiced painting this child on a scrap of canvas paper. I worked to capture the child's essence in a simple statement without using any fussy details. As you can see, the white canvas shows through here, but the preliminary ochre wash that toned the canvas shows through in the finished painting, uniting all of the colors in the painting.

Designing a Dramatic Waterfall

MATERIALS

SURFACE

20" x 16" (51cm x 41cm) cotton canvas

BRUSHES

Nos. 2, 4, 6 and 8 filbert bristles

No. 1 round bristle

OILS

Cadmium Red (by Winsor & Newton, or Grumbacher Red)

Cadmium Red Deep

Cadmium Yellow Deep

Cadmium Yellow Medium

Dioxazine Purple

Lemon Yellow

Permanent Green Light

Phthalo Blue

Quinacridone Red (by Grumbacher, or Winsor & Newton's Permanent Rose)

Titanium-Zinc White

Ultramarine Blue

Viridian Green

Yellow Ochre

OTHER

Facial tissues

Gum turpentine and jar

Palette knife

Pencil and paper

Ruler

When you find something you want to paint, identify what attracted you to it in the first place. Pinpoint the center of interest and visualize the emotional statement you want to make about it. Falling water seems to have a mystical quality to it that is challenging to capture. The ultimate goal is to make the viewer hear the roar of the waterfalls and almost feel the mist. This is what we will aim for in this demonstration.

Before you get started, flip back to the *Mix It Up* sidebar on page 94 for a refresher on mixing your secondaries and appropriate color substitutions.

Reference Photo

Plan Your Values
A vertical format is perfect for conveying the power of falling water and the upward thrust of growing trees. Your light source for this scene will be coming from the top right, and the foreground trees on either side of you will appear to be backlit. Make the scene predominantly dark, with a path of light zigzagging from bottom to top. Angle the fallen tree to lead the eye from left to right and upward. Avoid making these lines parallel with the bottom edge of the canvas.

Check the Overall Design
Simplify your value sketch to a two-value version to make sure that your plan is predominantly light or dark and that it suits the composition. The plus sign indicates the center of your canvas.

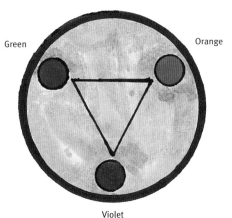

Green

Orange

Violet

Select Your Color Scheme
Plan for a secondary scheme with green as your dominant color, orange (Cadmium Yellow Medium plus Cadmium Red) for the rocks and the general color of the light, and violet for shadows and depth.

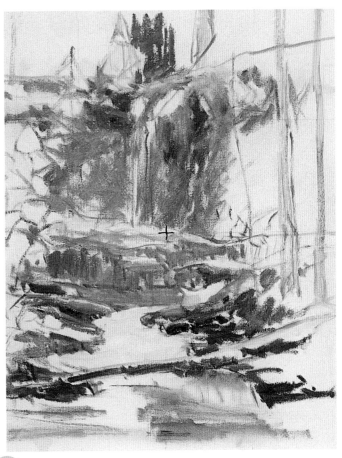

1 DRAW YOUR SUBJECT

An overall tonal wash is not absolutely necessary, so transfer your linear composition to your white canvas with your no. 4 filbert and Yellow Ochre. Grid your drawing and the canvas, dividing both into fourths or sixteenths. Make corrections to the drawing with a swipe of facial tissue and turpentine if needed.

2 BEGIN THE BLOCK-IN

Mark the center of your canvas with a plus sign. To avoid dividing this scene in half horizontally, do not emphasize contrasts in this spot. Begin blocking in your darks near the focal point at the top of the upper falls with a no. 8 filbert. Combine variations of Ultramarine Blue, Dioxazine Purple, Quinacridone Red and Cadmium Red Deep. Add a touch of white when needed to make tints. Keep the paint thin so it dries quickly. Block in the middle-ground rocks using tints of Yellow Ochre, Cadmium Red Deep and Ultramarine Blue. When roughing in the darkest shadows on shaded rocks, combine Cadmium Red Deep and Ultramarine Blue. Remember, place warm darks (browns) in the sunlit areas, and cool darks (blue-grays) in the shadows.

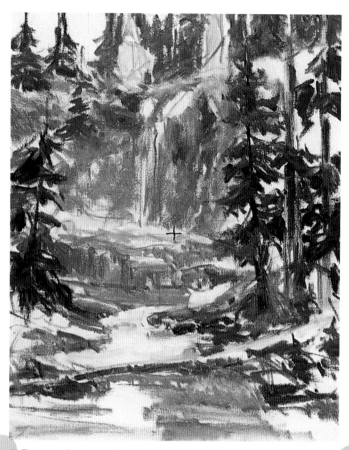

3 Block In the Dominant Color

On your palette, mix the local color of the trees. Start with Cadmium Yellow Medium and Lemon Yellow and then add Phthalo Blue, or mix Viridian Green with Permanent Green Light. Add a touch of Yellow Ochre to mute this bright color. Begin blocking in the trees, starting with the ones closest to you, duplicating the lights and darks in your value study. Keep your brushwork loose. For darker, cooler branches, add Ultramarine Blue. For the distant trees, add tints of Cadmium Red Deep and more Ultramarine Blue. Remember, modifying your local colors with yellow (ochre, in this case) moves them forward, and adding red and then blue makes them recede.

4 Refine the Block-In

Refine your block-in using the same colors with a smaller brush (a no. 4 filbert) until your canvas is nearly covered. Emphasize green, making it the dominant color in your secondary color scheme. Avoid defining harsh shapes or adding details yet. Keep your paint thin. The lightest areas here are still bare canvas. Check and double-check your painting for design problems because they are easier to correct now, before you get into thick paint.

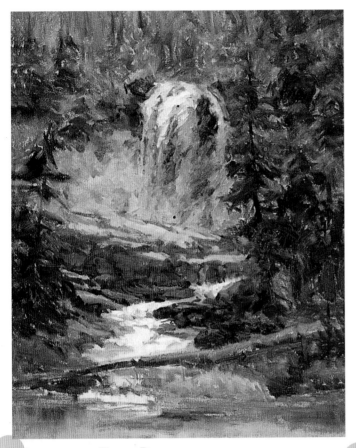

5 LAY ON THE THICK PAINT

With a palette knife, mix white with just touches of Lemon Yellow and Cadmium Yellow Medium directly on your palette. With your no. 6 filbert, apply this thick paint for the sunny whitewater in the middle ground. To suggest depth, eliminate the bright Lemon Yellow from this mixture for the water at the top of the falls. For both the water in the foreground and the sunny areas, use tints of Phthalo Blue. For the shadows and background, apply cooler tints of Ultramarine Blue. For the mist at the base of the falls, scumble tints of oranges, both blues and Dioxazine Purple.

Paint thick highlights on the rocks near the center of your canvas with various tints of Cadmium Yellow Deep, Yellow Ochre and Cadmium Red cooled as needed with Permanent Green Light. Develop shapes within your rocks, remembering to use thick paint in the sunlight and thin paint in the shadows. Dash Cadmium Red onto the sunny rocks and Cadmium Red Deep onto the shaded rocks, complementing your dominant color.

6 PAINT THE TREES ON THE RIGHT

Paint the darks of the trees first. On your palette, mix a variety of warm and cool green tints with Cadmium Yellow Medium, Lemon Yellow and Phthalo Blue. Neutralize them with Yellow Ochre, Cadmium Red Deep, Dioxazine Purple and Ultramarine Blue.

With your no. 4 filbert, develop the trees on the right side of the canvas. They are almost silhouettes since they are backlit. Keep the tops of the trees warmer (orangish greens) than their bottoms (blue-greens; cool your greens with Ultramarine Blue), indicating light filtering through the short limbs. Define a few edges, but don't overwork this area; you can return to it later to add the final details.

8 Develop the Distant Trees

Return to the top of your canvas and develop the distant trees. Alternate between painting the trees and the spaces between the trees. Modify your greens with tints of Dioxazine Purple and Ultramarine Blue. Don't create strong contrasts in this area. Don't depict clear details here, either; save details for the middle ground. Keep your brushwork loose.

7 Add Balance and Define Selected Edges

The single tree on the left doesn't have enough visual weight to balance the trees on the right side. Repeating the greens you used on the right, add another tree. Work back and forth between both sets of trees, adding branches and defining edges of the foliage. Paint negative spaces in the foliage with your background mixtures. Use a no. 2 filbert to paint some of the bright, sunny green mixtures between the branches. Drag a mixture of Yellow Ochre and Ultramarine Blue or Dioxazine Purple upward, redefining sections of your tree trunks.

9 Finish the Stream and Background

With your no. 2 filbert and no. 1 round, add details to the stream above and below the fallen tree. Use the same colors that you used to block in the water in step 5, and lay the paint on thick. Combine Cadmium Red Deep and Ultramarine Blue for thin, dark accents under the log. Reflect the dark foreground trees in the river with your left-over green mixtures. For these reflections, pull this thick paint down toward the bottom edge of your canvas with the side of your little finger. To indicate moving water in the immediate foreground, use a no. 6 filbert to paint a few horizontal lines just below the whitewater.

10 MAKE FINAL CHANGES AND ADD DETAILS

To enhance the unity of the colors in your painting, practice repetition with variety. For example, repeat the colors of the golden middle-ground rocks in the foreground water, add a few dashes of the whitewater colors to the falling water in the distance, and so on. Evaluate your painting to make sure that you didn't stray from your secondary color scheme. Since green is your dominant color, add touches of complementary reds with Cadmium Red and Cadmium Red Deep, particularly in the trees. Define as many edges and add as many details as you wish, but create an air of mystery around the main falls by leaving those edges soft.

MISTY WATERS • OIL ON LINEN • 20" x 16" (51CM x 41CM)

DIXIE'S DAISIES • OIL ON COTTON • 16" x 20" (41CM x 51CM) • IN GRATITUDE TO D. FOWLER

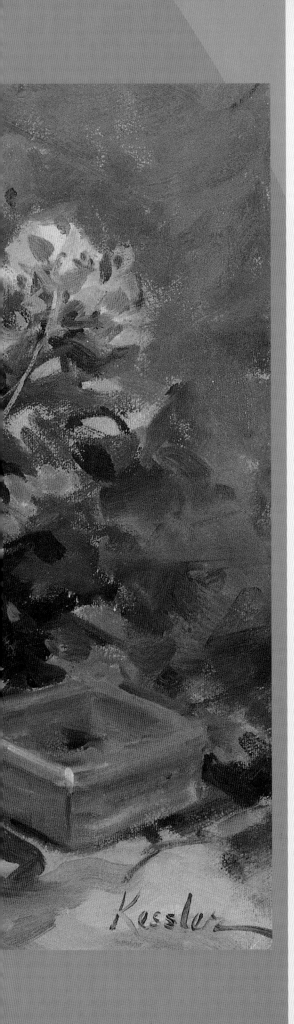

CONCLUSION

Color is a big subject. The possibilities are endless, but the fun is in the exploration. Just remember, the things you have read here are guidelines, not set-in-cement rules. This book is meant to show you some of the elements and principles of color, to improve your coloring skills, and to ignite ideas for using this information knowledgeably and, eventually, intuitively. This is a starting point, not an ending.

It has been said that the real subject of your painting is "you ... what you see, how you feel, your personal vision revealed." Bottom line: Study and experience life to its fullest. It will show in your paintings.

Index

The best in art instruction and inspiration is from **North Light Books!**

Create alluring works of art through negative painting—working with the areas around the focal point of your composition. Through easy to follow step-by-step techniques, exercises and projects, you'll learn to harness the power of negative space. Linda Kemp's straight forward diagrams for color and design, as well as troubleshooting suggestions and secrets, will make your next watercolor your most striking work yet!

ISBN 1-58180-376-1, hardcover, 128 pages, #32390-K

Whether your subject is Caucasian, Asian, African-American or Hispanic, this book provides practical guidelines for depicting realistic skin tones in your portraiture. Lessons and demonstrations in oils, pastels and watercolors teach you how to mix colors, work with light and shadow and edit your compositions for glowing portraits you'll be proud of.

ISBN 1-58180-163-7, hardcover, 128 pages, #31913-K

Bring new life to your paintings with this vivacious and liberating guide! With short sessions of sixty minutes or less, you'll focus your efforts on the essence of your subject, enabling you to master the medium rather than the tiny details that slow you down. Step-by-step demonstrations, examples and exercises make getting started easy. An hour is all you'll need!

ISBN 1-58180-196-3, hardcover, 144 pages, #31969-K

Create your own artist's journal and capture those fleeting moments of inspiration, creativity and beauty! Erin O'Toole's friendly, fun-to-read advice makes getting started easy. You'll learn how to observe and record what you see, compose images that come alive with color and movement, and make a travel kit for creating art anywhere, at any time.

ISBN 1-58180-170-X, hardcover, 128 pages, #31921-K